HISTORIC IMPRESSIONS

The History and Architecture of Joliet Homes

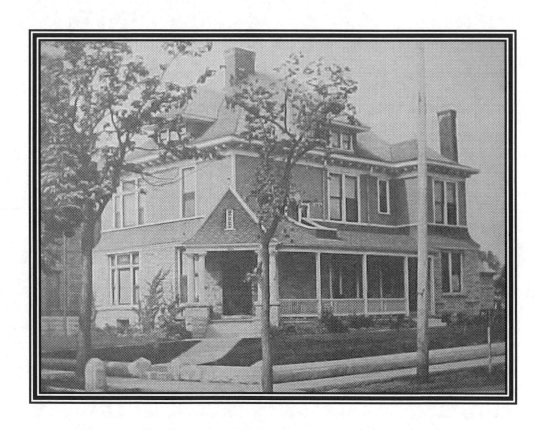

by P. Seth Magosky

Order this book online at www.trafford.com
or email orders@trafford.com

Most Trafford titles are also available at major online book retailers.

Print information available on the last page.

ISBN: 978-1-4120-7555-8 (sc)

Trafford rev. 07/17/2017

 www.trafford.com

North America & international
toll-free: 1 888 232 4444 (USA & Canada)
fax: 812 355 4082

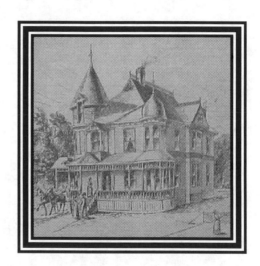

AKNOWLEGMENTS

I am very pleased to be able to bring this book to you. I have been researching the Social and Architectural History of Joliet for the past 20 years and have often in the past provided much information to local sources. It was through a chance conversation with Randy Chapman one night that the entire idea of a regular article came to light. I am very grateful to him and Jan Larsen for having the faith in me, putting up with me and helping me to create this wonderful series. I am pleased to bring these articles to you in a bound version for your enjoyment.

I have many people who have been helpful in my endeavors but first and foremost I must thank John for his patience while I run around getting pictures and sit closed in my office writing. I would also like to thank my parents Pat and Andrea Magosky for encouraging me to keep going in my love and interest in architecture and history.

Over the past year I have had the pleasure of being welcomed into many homes and would like to thank all of those who let me in to share their homes and stories. There have also been many people who have provided other information and or photos. All pictures are credited with each article. I would like especially thank Walter Keener and Kim Shehorn-Martin from the Joliet Historical Museum for their assistance as well as Roger and the archives staff at the Joliet Public Library for all their help.

DEDICATION

This book is dedicated to the loving memory of my Grandparents Willard Magosky 1912-2003 and Mary H. Krakar Magosky 1911-1993. Their many stories helped fuel my curiosity of the history of Joliet.

WEST SIDE

EAST SIDE

WEST SIDE

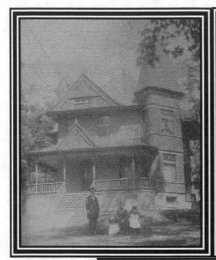
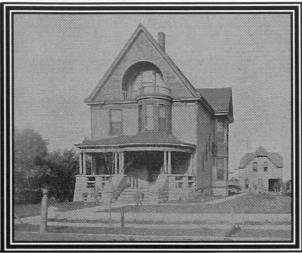
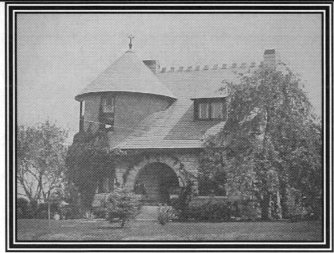

The Campbell, Bates, Flowers home, 500 Western Ave.

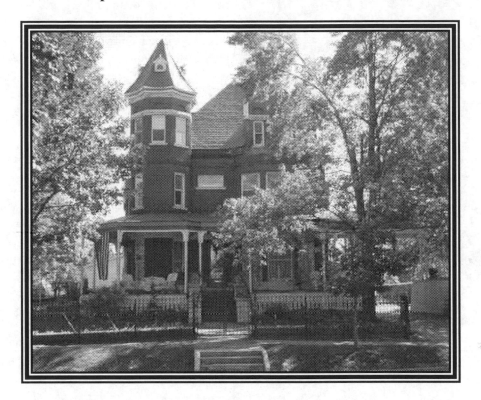

Why it's important: The home at 500 Western Ave is one the outstanding Queen Anne homes in Joliet. It has also been home to some of Joliet's prominent businessmen.

Style: The home at 500 Western is an excellent Queen Anne with Romanesque detail. The Queen Anne is seen in the asymmetrical massing, steep pitched roof, tall tower and wrapping porch. The Romanesque is seen in the arched motif if the top tower windows and dormer windows. It is also seen in the massive rough cutting or the basement stone and decorative elements. It is attributed to architect F.S. Allen who designed several structures similar to this home, and it contains some unique features only know to be used by Allen.

The history: The home at 500 Western sits in a tract of land subdivided by George Campbell in the last quarter of the 19th century. 500 Western is built on an oversized lot on the north east corner of this land. The first listing for the home appears in the 1890 directory listing the residents as Mr. Campbell and Mr. Odell. It is not clear if they just were building the house, or actually lived there, as they both appear at different addresses in the following directory.

Albert J. Bates appears around 1895-96. Without a close examination of the property between 90 and 96 it is unclear if the home was in fact built for the Bates family. The Bates family lived in the home until the early years of the 20th century when the home was sold to J.C. Flowers. It was Mr. Flowers who removed the original Queen Anne porch and added the large Neo-Classical porch and

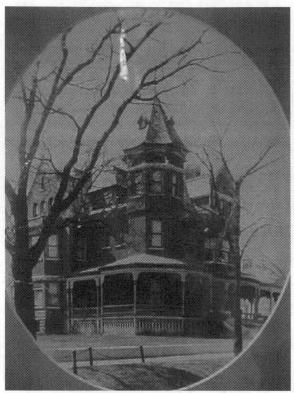

small room off the east side. The Flowers family would be the longest inhabitants, living in the home through the 1930s. The home passed through many other families including the Palmers of Palmer florist and Dr. Bagosi who was responsible for the removal of the Neo-Classical porch. The home at 500 Western was purchased by Brian and Tawnya Marshall in 2002.

Details: The home at 500 Western is full of outstanding features both inside and out. The exterior is a wonderful mix of elements including bays, tower, and dormers which create a very picturesque setting atop western Ave. hill. The front porch extends across the house and ends in a Porte Cacher at the west end.

The interior carries the wonderful details throughout the house. Inlaid floors are in all the formal first floor rooms. A massive Oak staircase rises from the entry, the entire three stories. The living room is dominated by a fireplace alcove with the original Romanesque mantel with its stylized foliage.

The Romanesque detailed foliage is picked up again in the built in China Cabinet in the dining room. This room also has the original French Tapestry wall covering. The other formal room is the library with a built in desk and bookcases.

The crowning glory of this house is the original Billiard Room on the third floor. It has the cue rack built into the wall, the original billiard table, and built in benches in the front dormer.

The people: George Campbell who was believed to be the original owner of the home made his fortune in Joliet in the stone business. He was owner of the Joliet Stone Company and then the Campbell and Dennis Company, still active in the stone business. He subdivided the tract of land the home is on in the 1880s and is believed to be responsible for the construction of the home.

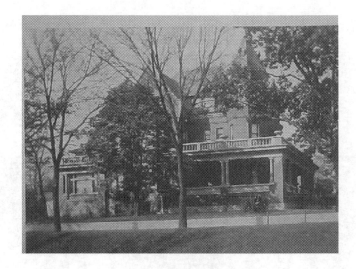

The house however quickly turned over to Albert J. Bates, who with his brother William O. Bates, founded the Bates Machine Company in Joliet. Mr. Bates came from Canada with his family to Joliet. In 1884 he and his brother founded the Bates Manufacturing Company. The company would become incorporated in 1888. The company produced machines to produce Barbed Wire and machinery used for diamond mining in South Africa. The company also produced farm tractors and road building tractors, including the Bates Steel Mule. Today the outgrowth of the Bates Machinery is the Caterpillar Tractor.

The next owner of the house was Dr. J.C. Flowers. Dr. Flowers was very important in early 20th century business in Joliet. His most notable role was that of Treasurer of the Gerlach Barklow Art Calendar Company and Volland Publishing in Joliet. It was Dr. Flowers who changed the look of the house by removing the original porch and adding the large brick neo-classical porch and side room in the early 20th century. This porch would be lost in the 1960s and the original porch would be restored in the 1980s by Dr. Gerald Vermulen.

Did you know? The doorway between the Living room, Entry Hall and Library is a "T" shaped arch. I have only seen this design in one other home, F.S. Allen's personal home on Morgan St.

Illustrations:
500 Western today, photo, author
500 Western ca. 1890, photo courtesy of Brian and Tawnya Marshall
500 Western, Come to Joliet, 1905, courtesy of Joliet Public Library
500 Western, 1916 Artworks of Joliet, courtesy of Andrea Magosky
Dr. J.C. Flowers ca. 1920, courtesy of Tim Smith

The W.A.S Brooks house, 505 Western Avenue.

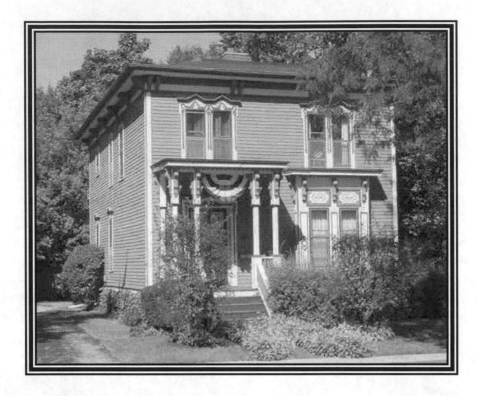

 Why it's important: The Brooks house is the last remaining home of the prominent Brooks family, it is also one of the few documented designs of architect James Weese.

 Style: The Brooks house is a classic example of the Italianate style. This is seen in the flat topped roof, heavy corbels on the roof mine, and the paired windows with elaborate window hoods.

 The history: The Brooks house was constructed in 1875 in the newly laid out Glenwood Subdivision. It was designed by local architect James Weese in the Italianate style and remains today his most intact 1870s design.

The home was owned by Charlotte Brooks, wife of W.A.S. Brooks. Charlotte was the niece of William and Charlotte Strong, the couple responsible for laying out the subdivision and who lived in the house now located at 306 Nicholson.

The home was owned by the Brooks family until 1944 when it was sold to Henry and Francis Simpson. It was then sold several years later and converted into three apartments. It was during the second and third owners that many alterations were done including two porch remodeling and the addition of aluminum siding.

The W.A.S. Brooks home is today owned by John and Patty Kella. Patty rented an apartment in the home in 1973. In fact her first date with John was when she first rented the apartment in the home. They were married in 1975 and purchased the home in 1976.

8

In 1987 they started the major restoration of the exterior of the home. They were inspired by the house across the street being restored and were caught up in the restoration fever that was starting to spread along Western Ave. Patty recalls it was their opportunity to put something into the outside of the house to give back to the community.

 Details: The Brooks home is a classic Italianate home from the small front porch to the trapezoidal bay on the east side. Many features have been restored such as the elaborate window hoods which were hidden under aluminum siding for years. The Eastlake style double doors were added by the current owners during the restoration.

The interior is a simple basic plan with an entry hall with a curving staircase with a large newel post done in the Eastlake style typical of Mr. Weese designs. There are still many original doors including the pocket doors between the main formal rooms.

Much of the original interior has been lost due to various remodeling over the years. One very unique feature that remains though is the hardwood floors. These are not your average floors, but instead the wood is in very narrow strips, about one half to one third the width of usual floors.

The people: W.A.S. Brooks was a hardware merchant in the business founded by his father and partner W.A. Strong. He also served as Treasurer of Joliet Wire and Fence which originated in 1866.

Mr. Brooks was married to Charlotte who was a relative of Charlotte Strong wife of W.A. Strong. This is an interesting match as the elder Mr. Brooks was married to Sarah Strong sister on W.A. Strong.

The strong family owned the home on Western all the way into the 1940s, though they would only reside in it for most of the 19th century. The family then moved to the east side, perhaps the family home inherited there, and rented the Western Ave. home until they sold it in 1944.

Did you know? All of the streets in the Glenwood Subdivision are named for members of Charlotte Strong's family, hence Brooks street is named for W.A.S. and Charlotte Brooks.

Illustrations:
505 Western today, photo author

The Eneshia Meers home, 604 Western Ave.

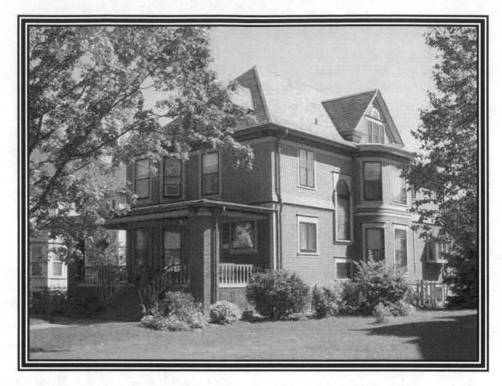

Why it's important: The Eneshia Meers home is a very nice example of late 19th century Colonial Revival architecture. It is also the home of one of the most prominent lawyers in Joliet around the turn of the century.

Style: The Meers home is a 2 and a half story Colonial Revival home. The style is seen in the Palladian motif in the attic dormer and details around the stained glass staircase window on the west side of the house. A large brick porch extends across the house where a Classical porch with columns used to be.

The history: Constructed in 1897, the Meers home was the third house in a row built on this side of the 600 block of Western Ave. The home was fist owned by Eneshia Meers and his wife Annie. The Meers family had joined the move from the east side of Joliet to the west side with the construction of this home, their prior home being on the 100 block of Eastern Avenue.

The Meers family would live in the house until 1916 when it was sold to Mr. Gibson. In 1921 Dr. Walter Huey purchased the home and the Huey family would reside here through 1956 becoming the longest residents of the home.

The house fell on hard times during the early 1960s, being used as a boarding house, though fortunately nothing as done to destroy much of the original features. Subsequent owners though started the long restoration process.

The Eneshia Meers home was purchased by Wayne and Bonnie Horne in 1995. They lived in northern Will County, and were interested in purchasing an old home. They liked the Joliet area and looked at some homes in the Cathedral area. When they saw the pocket doors and leaded windows they fell in love with the house. The Horne's have done much painting and decorating in the house. One of their major contributions was the restoration of the large stained glass window on the staircase.

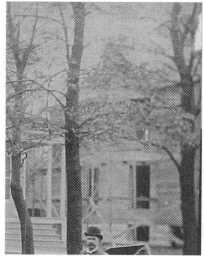

Details: The Meers home stands as one of the great spacious homes lining Western Avenue. The house is entered through a small vestibule and into a larger entry hall with beautiful oak woodwork and impressive staircase. The hall has several leaded glass windows including the ones in the front doors and the massive stained and leaded window on the landing of the staircase.

The formal double parlor of the late 19th century has been open to a single room as was common to do in the early 20th century. The dining room to the rear of the hall has original curved glass windows at the corners. Pocket doors and an abundance of beautiful oak woodwork set off the rest of the rooms in the house.

In the entry hall hangs a portrait of Eneshia Meers left by previous owners as part of the house. Also of interest are the spindles of the staircase. There are 2 different styles of spindle per step, a common decorative element in the late 19th century interiors.

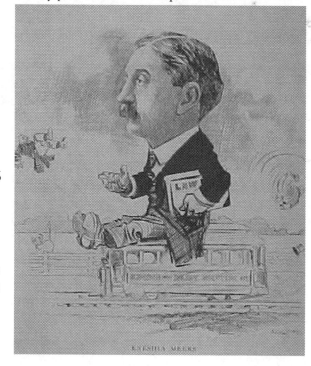

The people: Eneshia Meers was born in 1855 in New Jersey. He received his early education in the Public Schools of New Jersey. He attended Seaton Hall in South Orange, New Jersey, and graduated from Law School in 1876 from the University of Michigan.

After graduation he set up a law practice in Joliet. He was elected City Attorney for 2 terms. In 1894, Eneshia married Annie Scott in St. Louis. At the time of the construction of his house he was senior partner of the law firm Meers and Barr. He worked with Richard Barr and also John Downey during his years in

practice. His offices were in the Young building on Jefferson Street.

Did you know? Eneshia Meers was the founder of the Will County Bar association.

Illustrations:
604 Western today, photo, author
Eneshia Meers, 1897, Joliet Illustrated, courtesy of Joliet Public Library
604 under construction, courtesy of the Miller family
Eneshia Meers, Illinoisans How We See Them, 1900, courtesy of Joliet Public Library

The Walter B. Stewart House, 606 Western Ave

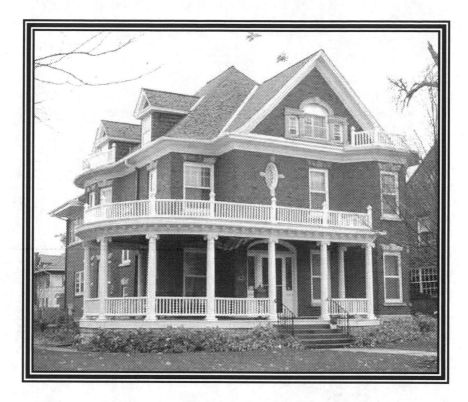

 Why it's important: The Walter Stewart house is an excellent example of the early Colonial Revival style. Mr. Stewart was also one of the most prominent physicians in Joliet at the turn of the century.

 Style: The Stewart house is a beautiful mix of the Colonial Revival and the Queen Anne styles. The Queen Anne is seen in the asymmetrical massing with of the house and the large octagonal tower dominating the corner. The Colonial Revival is seen in the Palladian window in the attic, the elliptical fan light window above the door, and the heavy classical porch.

 The history: Walter B. Stewart purchased the land for this home in 1901. The house was constructed sometime between then and when he first appears at this address in the Joliet city directories in 1905.

The house was constructed at about the mid point of development of the 600 block of Western Avenue. The house has a small garage in the rear which is in a similar design to the main house. Also of interest is that it is the only house on its block that has a drive that cuts through to Western.

The house went through several owners over the 100 years it has been standing. A kitchen was added to the rear and several interior changes were made. The main thrust of restoration was done in the 1980s by its former owner.

The Stewart house was purchased by Ben & Bettie Komar in 1999. They lived just outside of the Cathedral area for several years in a 1920s bungalow. They often walked the Western Ave. area and were very fond of early 20th century homes, and especially liked the one at 606. When it came on the market they were interested, though it would be a while until all the pieces fell into place and they purchased the home.

Details: The grandeur of the Walter B. Stewart house is noticeable from the elegant leaded glass of the entry all the way through the house. The home opens into a vestibule and then into a spacious hall with a massive oak staircase.

A massive oak fireplace mantel in the living room was added during the restoration, as were the period light fixtures. The second floor has several bedrooms in the front of the house two of which still have their original marble sinks. There is also a service area in the rear with the original bathroom and servant's room.

The third level of the house was finished sometime after the house was built. A larger kitchen was added to the house with a sunroom above it on the second floor.

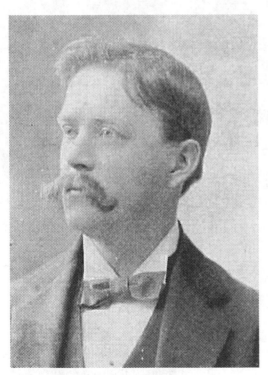

The people: The home at 606 Western was built for Walter and Gertrude Stewart. Walter was born in 1866 in Wilmington IL to John and Lettie Stewart.

He graduated from the University of Illinois in 1884. He then attended the Chicago College of Pharmacy and graduated there in 1885, finally he attended the College of Physicians and Surgeons in Chicago in 1888.

Among the various jobs that Mr. Stewart had he was house surgeon at St. Joseph Hospital, County Physician for 6 years, and Surgeon for the E.J. & E. Railroad.

He lived in the house until 1927 when he sold it to Frank and Elizabeth Kelly. He then moved in an apartment in the Mary Walker Hotel at Western and Pine.

Did you know? Today we find it odd to have a sink in the bedroom. In the early 20th century the sink was a high tech alternative the usual pitcher and bowl on a wash stand.

Illustrations:
606 Western today, photo, author
Dr. Walter B. Stewart, 1897, Joliet Illustrated, courtesy of the Joliet Public Library

The Edward C. Barrett house, 612 Western Ave.

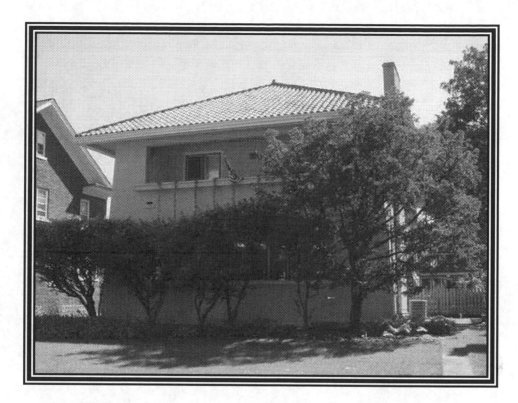

Why it's important: The Edward Barrett home is one of the finest Prairie School influenced houses in the city of Joliet. Aside from the architectural design, Edward Barrett was a member of the prominent hardware store family in Joliet.

Style: The E.C. Barrett home is a wonderful example of the Prairie Style of design. The home is low to the ground with a wide low hipped roof. The overall aim of this style is to make the house seem low and one with the surrounding prairie. The house is constructed of hollow clay tiles covered with stucco walls and clay tile roof which accentuate the natural feel of the home.

The history: The Barrett home was constructed in 1910 on the 600 block of Western Ave. That same year there were 3 houses in a row being completed at the same time. The home was designed by local architect C.W. Webster. Mr. Webster's other works include First Pres. Church, Lincoln, Washington, and Eliza Kelly Schools, and the old Willow Ave. Pres Church. The Barrett home cost $7138.90 according to original receipts the current owners have.

Robert Shoemaker and Joanne Potenziani purchased the house in 1977, and are the 4th owners. Bob recalls a couple years after he moved into the house receiving a telephone call from Barrett's downtown stating they were cleaning out a desk and came across an envelope of information about the house. The envelope included the original costs of building and furnishing the house among other interesting documents.

Details: One of the most notable features of the E.C. Barrett house is the full front porch which is

15

incorporated into the overall body of the house. The first floor has a long low arch that is accented on each end with small Art & Crafts details. There are French doors which lead from the large living room out to this porch. The same layout is copied on the second floor. The front door of the house is actually tucked into an arched recessed porch on the east side of the home. This creates a more casual informal entrance keeping the ideals of the prairie style going through the design.

You enter the home into a central hall. To the right is a large formal living room which leads out to the front porch. The west wall is decorated with a fireplace with flanking bookcases. To the left of the entry is the formal dining room and behind it, the kitchen. The main focus on the entry hall is the oak staircase which rises to the bedrooms.

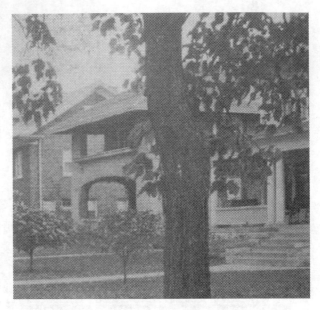

The people: Edward Barrett was born in Joliet in1864, the son of William and Clamana Barrett. Edward Barrett graduated from Joliet High School and immediately entered the Barrett & Son shops. There he learned the plumbing, heating, and sheet metal trades. At age 20 he became the head of the tinning shop. Edward went on to become the secretary and treasurer of Barrett's Hardware. His son W. Franklin became president after he graduated from University of Pennsylvania in 1919. Edward lived in the house until his death in 1941, his widow Antoinette remained there until the house was sold in 1961.

Did you know? In 1951, the Barrett family added an elevator from the entry hall to an upstairs room to ease the movements of the elderly Mrs. Antoinette Barrett widow of Edward Barrett. The elevator cost $2365.00 to have installed. The current owners have the work receipt for the work.

Illustrations:
612 Western today, photo, author
612 Western, 1916 Artworks of Joliet, courtesy of Andrea Magosky

The Dr. Philip Le Sage home, 619 Western Ave

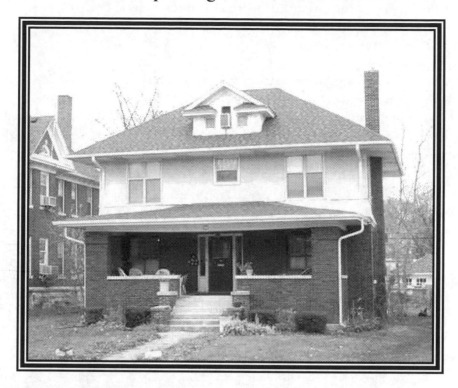

Why it's important: The home was occupied by one of Joliet prominent doctors. It was also designed by noted local architect Charles Wallace.

Style: The LeSage home is a classic American Foursquare with some Colonial Revival overtones.

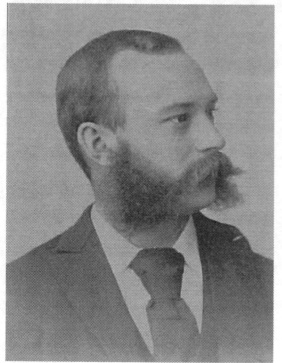

The foursquare home refers to the lay out of the home, a basic square. This one is also embellished with a full front porch and rear kitchen wing. The Colonial Revival touch is seen in the Palladian window in the front dormer.

The history: The Dr. LeSage home was constructed around 1914 at what was then 707 Western Ave. The house was one of the last homes to be built in this block of Western Ave. The home has survived in pretty much original condition over the years with few alterations to the original character both inside and out.

Some decorative elements were removed over the years that appear on the original plans still in possession of the current owners. This includes the original fireplace and oak columns that would have been between the entry hall and the living room.

17

The LeSage home is today owned by Vincent and Fran Cerri. They purchased the home in November of 1975. Fran was pregnant with her son when her husband drove by a house he liked for sale. They looked at it and purchased it. Fran recalls it was the only house the really looked at. Vincent is a great lover of old houses and has thoroughly enjoyed this one.

Details: The Dr. Philip LeSage home is a classic foursquare. From the long porch with heavy brick piers to the typical plan everything is perfect in the design. Although at first glace the home appears rather simple, there are many fine subtle features. The house has a simple flare between the first and second floor, this is noticeable on the sides of the house. Also there are very attractive Arts & Crafts style windows on the main level.

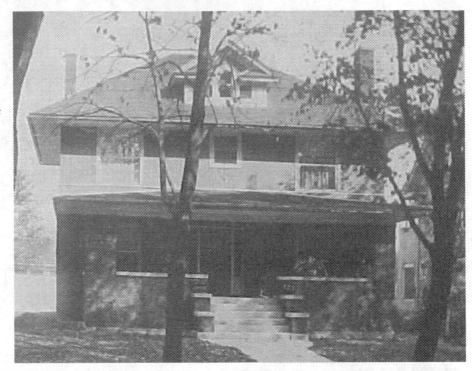

Once inside the home you enter through the vestibule to a full hallway with an oak staircase rising at the end with beautiful Arts & Crafts stained glass windows. Stained glass is again used in a set of three windows on the west wall of the dining room. The entire house has oak woodwork which is quite simple on the main doorways, but is somewhat more elaborate when it comes to the beamed ceiling in the dining room and ceiling trim in the living room.

The people: Philip LeSage was born at Bourbonnais Grove near Kankakee, October 20, 1865. From 1875 until 1886, Mr. Le Sage attended St. Viator's College and received a bachelor of arts. In 1887, he began study at the Chicago Medical College, now the medical school at Northwestern.

He graduated with a medical degree in 1890. He was able to catch a coveted position as an interne at Mercy Hospital, Chicago. He would remain there for one year before setting up private practice in Chicago where he remained until 1896 when he moved to Joliet. Dr. LeSage served over time in many organizations and worked as a medical examiner for John Hancock Life Insurance Company and Aetna Life Insurance Company.

When Mr. LeSage moved to Joliet his home was on the corner of Herkimer and Benton in a handsome duplex. Around 1914, he constructed his handsome home on Western Ave. Dr. Le Sage and his wife Elizabeth would live in the home into the 1940s.

Did you know? Aside from working as medical examiner for insurance companies, Dr. Le Sage was also examiner for the Catholic Order of Forrester's and the American French-Canadian Association, both organizations he was a member of.

Illustrations:
619 Western today, photo, author
Dr. Philip LeSage, 1897, Joliet Illustrated, courtesy of Joliet Public Library
619 Western, 1916 Artworks of Joliet, courtesy of Andrea Magosky

The William Wallace Wood house, 712 Western Ave.

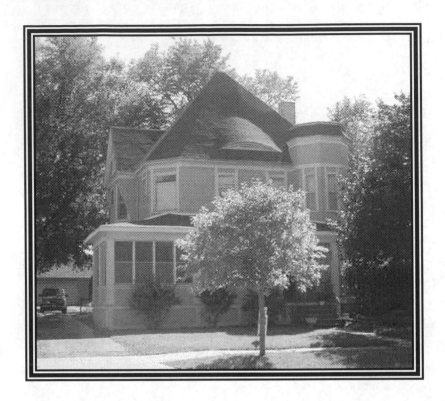

Why it's important: The William Wood home is very nice example of the grand Victorian homes that line Western Ave. It is also the home of the patriarch of the Wood family who were well known in Joliet.

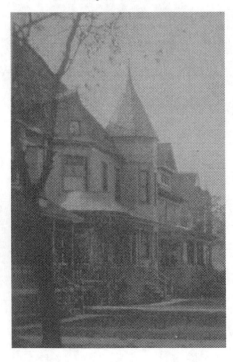

Style: The Wood home is a large Queen Anne style residence built in 1896. It also has Stick Style overtones. The Queen Anne is seen in the asymmetrical massing with the tower dominating the west side. The Stick Style is seen on this home in the flat boards, or sticks, that separate the siding into panels.

The history: Constructed in 1896 by William W. Wood, the home at 712 Western was one of only a handful of large homes built on this part of the street. The house when originally constructed had a pointed cone on the tower, dormer on the north east corner of the roof and a spectacular spindle porch across the front. Some time in the 1920s the original porch was removed and a large Classical style porch was added. This new porch was constructed with window enclosures which were replaced with the current porch windows in the 1960s.

The tower cone and dormer were removed in the last half

of the 20th century in order to ease the roof maintenance. It is believed it was around this time the house was divided into 2 units, one up and one down.

The Wood home was purchased in 1995 by Philip and Rosalie Jostes. They owned a new Cape Cod style home in New Lenox. With a growing family they decided it was time to either buy a larger house or add on to their existing one. They have worked over the years restoring the house to the original layout and reinstalling the staircase railing. They have also restored the fireplace in the entry hall.

Details: The W.W. Wood house is a beautiful Queen Anne home with all the typical attributes of any fine Victorian home. The house opens to a spacious entry hall with a fireplace nestled into the corner. There is an oak banister and a large set of pocket doors leading to the parlor.

When the house was divided into 2 units this entry was closed in and the stair rail was removed as well as the pocket doors. The current owners found the staircase elements in the attic of the garage, and the pocket doors in the attic of the house. They have been working on restoring all these elements to their original places.

The double parlor off the entry hall has been opened into a single room. This was a common alteration made in the mid 20th century.

The people: William Wood was born in 1835 in New York. He married Cleora on October 17th 1861, and moved to Will County in 1864. He built a farm near Elwood and prospered. It was there he raised his family. The children were Hattie, Emma, Frank, Blanche, Alice, Jessie, Harvey, & Homer.

In 1895 William retired from farming and constructed his residence on Western Ave, then addressed number 816. He would live here until his death in 1913 of deterioration after a stroke. At the time his son Harvey was mayor of Joliet. His widow would remain in the house until her death in 1930.

H. Wood

The eldest daughter of the Woods was Hattie Wood. She was a math teacher at the High School for a great many years. She would be the longest Wood resident in the home, living there until her death in 1949. She was a well respected member of the faculty of the school and the 1911 class book contains a wonderful special dedication page to her.

Did you know? In the 21st century we think of retiring into a smaller home, while in the 19th century many men such as W.W. Wood built grand homes to spend their last years in.

Illustrations:
712 Western today, photo, author
712 Western, 1916 Artworks of Joliet, courtesy of Andrea Magosky
Hattie Wood, 1927 Joliet High School Year Book, courtesy of Joliet Public Library

The Keokuk Booth house, 719 Western Avenue

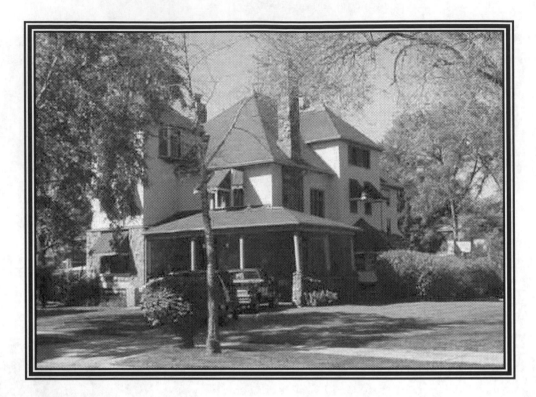

Why it's important: The Booth house is a prominent Queen Anne structure on Western Ave. It stands as one the early grand homes of this street.

Style: The Keokuk Booth house was constructed as a massive Queen Anne style home with sweeping cut shingle details and stained glass windows. Although the Queen Anne massing is still visible in the tower and steeply pitched irregular roofline, after an early 20th century remodeling, the home takes on an English Arts and Crafts overall feel.

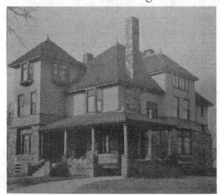

The history: The Keokuk Booth house was constructed sometime between 1887 and 1895. It was built is what I commonly refer to as the first wave of building on Western Avenue. When it was constructed, there were only a handful of houses this far out on Western Ave., and nothing else in the general area as can be seen in the original photo.

The house remained in the Booth family into the early 20th century. The home was sold to the Fegan family of Fegan's Jewelry store around 1905. The next famous owner of the house was Mr. Felman, owner of the Boston Store in downtown Joliet. It was during these years that the home was remodeled and achieved its current look. From that point on, the house would continue down the Felman family line until it was purchased by the current owners.

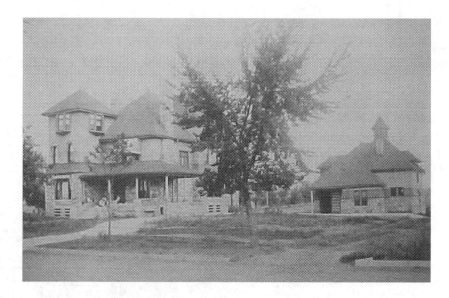

The Booth house was purchased by Dennis and Diane Izral in 1993. It was just prior to that when they were blessed with triplets Stephanie, Melanie, and Natalie. They lived in Lockport at the time and suddenly need a larger home. They have done extensive restoration on the interior including stripping woodwork, refinishing floors, installing period lighting, and decorating the rooms with spectacular period wallpapers.

Details: The Booth home sits very stately on the corner of Western and Raynor avenues. The large porch extends to the east and ends in a Porte Cacher, or carriage porch. The house is entered through wonderful double doors with full length windows.

Upon entering the house you pass through a vestibule into a small entry hall. When the house was constructed this was a spacious hall with a fireplace and a grand staircase. The front part was converted by the Felman family to a bathroom and powder room. Through doorways with pocket doors, you enter either the large parlor or the formal dining room. Both rooms have natural woodwork and wainscoting around the bottom.

Other features of the house are the original butler's pantry with extensive cabinets, servant's buzzer in the floor under the table in the dining room, a pull cord servant call system, and original sinks in the bedrooms fed from water pipes in the attic. Odd features left in the house include an original very early gas dryer in the basement.

The people: Keokuk Booth was born in 1857 in Libertyville, Ohio. When he was 14, Keokuk came west with his brother Harry to Chicago. While there, he worked as a clerk in a clothing store. It was while living in Chicago he met and married Susan Smith.

They were married in 1884, and shortly after their marriage they moved to Lake Geneva, Wis. He was engaged in the hardware business with T.C. Smith. After the death of Mr. Smith in 1887, he came to Joliet.

Here he established a laundry business. His laundry grew to three story operated by steam and furnished with modern appliances. He was active in Laundrymen's associations, and helped establish the Illinois State Laundrymen's Association, and was elected their second president.

Mr. Booth died in 1899; he and his wife had three children, none of which survived. Mrs. Booth continued operating the business created by Keokuk into the early 20th century.

Did you know? The first Mrs. Felman to live in the home considered the old stained glass window too dark and out of style and removed them all replacing them with the current windows.

Illustrations:
719 Western today, photo, author
719 Western, 1913, Greater Joliet Illinois, courtesy of Joliet Public Library
719 Western, 1895 Artworks of Joliet, photo courtesy of Joliet Historical Museum
Keokuk Booth, 1890, Portrait and Biographical Album of Will County, courtesy of Joliet Public Library
719 Western Carriage house today, photo, author

The John Theiler home, 428 Buell Ave.

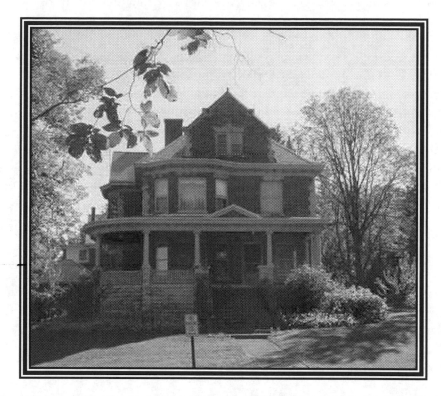

Why it's important: The Theiler home is not only associated with a prominent local businessman, but also is the finest example of Jacobean architecture in Joliet.

Style: The John Theiler home is an excellent example of the Jacobean style. This is seen mostly in the way the dormers are decorated and the style of the window hoods. Also typical to this style is the use of Quoins, or contrasting stone at the corners for a decorative effect. The Jacobean style is a revival of the style used during the Post-Elizabethan era in England.

The history: The home at 428 Buell was constructed for the family of John Theiler. The land is part of the original holdings of Joseph Campbell. In the 1860s development started in the area with Glenwood subdivision. It appears the block which contains this home was held with the original homestead until the turn of the century. Many fine residences were built across the street and in the area in the 1870s and 80s, but nothing appears to have been constructed in this area until after 1900.

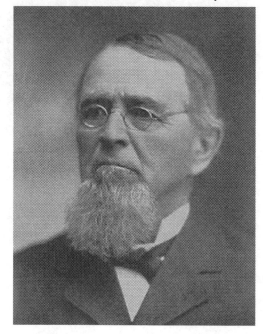

The fine residence was constructed in 1905 and would pass from the John Theiler family to a daughter and her husband Casper Wanner. The home then stayed in the Wanner family until the current owner purchased it.

The Theiler home was purchased around 1960 by Lewis Bank from descendants of the original family. The Bank family still lives in the home and continues to maintain it is excellent condition.

Details: The Theiler home is a splendid residence from the fist impression outside, to the stunning interior. The home is perched on a hill overlooking the Buell Ave. valley and compliments nicely the Lagger home across the street. The Jacobean details add a slightly exotic feel to the house compared with the simple four squares and Colonial Revivals on either side.

The wrap porch, with classical features gives a stunning view of the street. The interior of the home is no less grand. The house was outfitted with stunning oak molding with a massive grand staircase in the entry hall with a beautiful stained glass window. The Jacobean influence transfers to the interior as well. A Gothic arch recess on the staircase and massive bronze gothic hardware sets off the rest of the entry. The dining room has the original plaster moldings along the ceiling and built in china hutch. The other great features include the original oak pier mirror, and oak framed portraits of the original owners found in the attic.

The people: John Theiler was born in Switzerland on December 8th, 1829. He came with his family to New York in 1847. By 1850, he had made his way to Joliet and was working in George Woodruff's Distillery. In 1853, he settled permanently in the Joliet are purchasing a farm on the far north end of North Broadway. In 1862, John moved again and opened a store on Bluff St. This was located at 110 South Bluff and was expanded over the years to include several stories and addresses.

In 1892 John Theiler assisted in the incorporating of Porter Brewery, which he was a stockholder and director. Among his other business pursuits were the platting and sale of land along West Park Street car line, and Manager of Theiler Park which was located on a portion of his old farm land. He also was involved in the Sharpshooters Association and was a prized marksman.

Mr. Theiler was married to Lizzie Fender who came to Joliet with her father in 1846 from the Alsace region. They had 5 children who lived to adulthood. These were John and Joseph who were prominent men in their own rights in Joliet, and Mary Scheit, Lizzie and Louisa who married Casper Wanner.

Did you know? The Theiler Park on Broadway Street survives today as an entertainment spot, it is now know as Haunted Trails.

Illustrations:
428 Buell today, photo, author
John Theiler, 1905, Genealogical record, courtesy of Joliet Public Library
428 Buell, 1927, Joliet Evening Herald, author's collection

The Sebastian Lagger home, 429 Buell Ave.

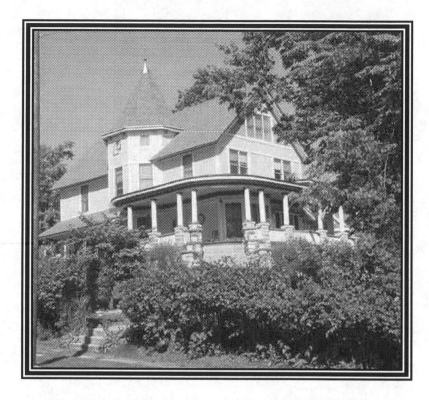

 Why it's important: The Lagger home is not only a wonderful example of the Queen Anne style. It was also the home of prominent businessman and mayor of Joliet Sebastian Lagger.

 Style: The Lagger home is a classic example of the Queen Anne style. This style is seen in the steeply pitched roof, 3 story tower which dominates the west side of the house, and delicate spindled back porch. The front of the house is dominated by a large wrapping porch which is built in the Neo-Classical style, and which was probably added around the turn of the century to the house.

 The history: The Lagger home was constructed around 1885 on a high lot overlooking Buell Ave. It was one of 4 large impressive home built along this block in the 1880s. Unfortunately only 2 remain today. When originally built it had a smaller spindled front porch which went across the front of the house.

The house passed from the Lagger family around the turn of the century to the Flynn family. They would own the house through the early 20th century and were probably the family responsible for the porch addition. Eventually the Romano family purchased the house. They added a swimming pool (since removed) and

put in stairs from the front of the house all the way down to Buell changing the original design.

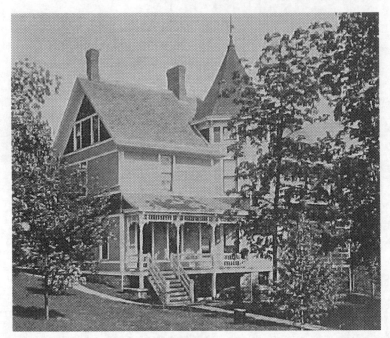

By the 1960s, the house was divided in a 3 unit, but was brought back to a single home in the 1970s. It was around that time that the house was decorated as a showcase house for St. Joseph hospital, and then auctioned off.

Rebecca Darley purchased the home in 1988 with her late husband. They had been looking for an old home and Rebecca recalls breaking into tear when she saw the home "I just loved it so much". They purchased the home around the time that the area was making a positive turn and she was happy to be part of it.

In 1994 a fire swept from the basement up through the main block of the house, burning floors and woodwork. After that tragedy, they started to put the house back together and restore it fully. It was during the reconstruction that Mr. Lafond died and Rebecca met Karl Darley who was the main contractor on the house. Karl had been very familiar with the house, actually working on it before Rebecca owned it.

The two eventually married and they have lovingly restored the home

Details: One approaches the Lagger home by way of a beautifully restored exterior staircase on the front, and then enters a wonderful interior. The entry hall is dominated by the large oak staircase with various Victorian carved details.

From the entry hall you enter into a long parlor which at one time would have been two parlors. As with a great many early homes though, these two rooms were merged into one. The fireplace at the end and the oak floors are replacements for the original ones which were lost in a fire.

The dining room has a massive built in china cabinet, and the dining room exits to the kitchen, and also a small study or office.

The people: Sebastian Lagger was Mayor of Joliet in 1895. During his life he was associated with several prominent businesses in Joliet. Among those were the German Savings Bank, the Joliet National Bank, and the E. Porter Brewing Company.

Before being elected mayor, Mr. Lagger served as alderman of his ward for 12 years. He was well known as a very devoted mayor, committing much of his time to the office. He was noted as being particularly interested to make sure the city had good streets and sewage system.

Mr. Lagger is buried in St. Johns Cemetery on Ruby St.. His monument is the large crucifixion scene that can be seen passing the cemetery.

Did you know? According to newspaper articles, the Lagger home was the first in Joliet to use electric lighting. It states that they used the electric for Christmas lighting.

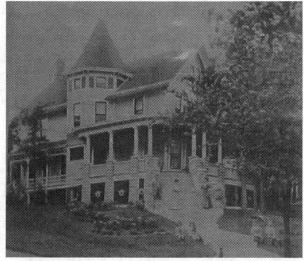

Illustrations:
429 Buell today, photo, author
Sebastian Lagger, 1897, Joliet Illustrated, courtesy of Joliet Public Library
429 Buell, 1897, Joliet Illustrated, courtesy of Joliet Public Library
429 Buell, ca. 1910, courtesy of Karl and Rebecca Darley

The Herman C.L. Stoll house, 501 Buell Ave.

Why it's important: The Herman Stoll residence was the home to one of the key real-estate and loan men in Joliet at the end of the 19th century.

Style: The Stoll house survives today as a Colonial Revival home with an imposing 2 story portico on the east façade with large multi paned windows flanking. The roof though tells a different story, the steep pitch, irregular massing and eyebrow windows reveal the Queen Anne style which the home was actually constructed in.

The history: The Stoll house was constructed around 1892. Set atop the steep ridge on Buell, the site was an excellent choice to place a stately Queen Anne home. A three story tower dominated the south east corner with large wrapping porches with heavy turned posts and delicate spindles.

The house remained in this style through the time that the Stoll family lived there. In the late 1940s the house was sold out of the family and city directories show this is when the home was transformed into the duplex it is today.

The house was literally cut in have inside. Two staircases were added in the central core of the house while the original front and rear staircases were removed. The floor plans were changed and create two mirror image units. The orientation of the house was also changed from Buell to Nicholson. It was during this remodeling that the tower was removed and the porches stripped off.

The Stoll house was purchased in 2004 by Bill and Kim Hendrick. Bill is a native of Joliet and Kim came to Joliet from Orland. They owned a home on Wilcox St and often walked through the area

looking at homes. They had always been impressed by the large sweeping yard and imposing nature of the house.

Details: The Stoll house is an interesting assemblage of parts from the original Queen Anne design and the Colonial style superimposed onto the structure. During the 1940s remodeling much of the original woodwork was reused in the home, this helps current owners understand the interior style of the home. Also evident are many original doors and ornate Eastlake style hardware.

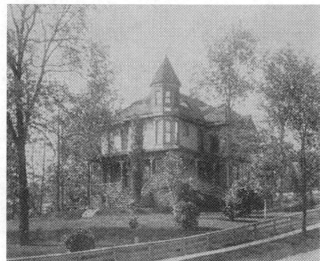

While going through the house many interesting tales can be told from the elements in the basement. Trapezoidal bays windows were removed from the east and west facades, a central chimney was removed as well as the all of the original interior staircases, though a trip to the attic reveals the placement of some of the missing parts.

The exterior also tells its own story, the stone pad for the large front stairs leading to the porch is still in place, and close observation or foundation lines reveals the dimensions of the tower.

The people: Herman C.L. Stoll was born in 1857 in New York City, His family moved to Mokena IL where he was raised. He graduated from the public schools of the area, and also attended German School. He worked a Dry Store Clerk, and later a hotel clerk until opening his real-estate office in Joliet on February 15th 1890. He married Henrietta Schiek in 1879 and they reared 7 children.

His business has extended into Estate Administration and Land investments. Aside from doing business in Joliet and around Illinois, he also deals with land in the Northwest and Western Canada. He was a member of the Union League Club of Joliet and the Commercial Club of Winnipeg, Manitoba, Canada.

The Stoll family would reside in the stately home through the late 1940s when the home was finally sold out of the family. It was at that time to conversion into a Duplex took place.

Did you know? Although the Queen Anne style is named for Queen Anne of England, the style has nothing to do with the architecture of the period in which she lived. In fact it started as a very rough interpretation of late Tudor architecture.

Illustrations:
501 Buell today, photo, author
501 Buell, 1905, Come to Joliet, courtesy of Joliet Public Library

The John W. Downey house, 509 Buell Ave

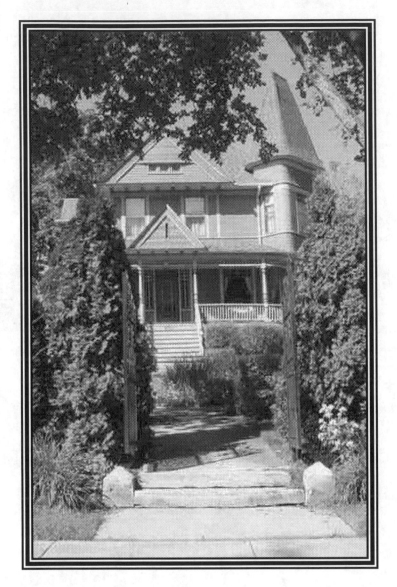

Why it's important: Aside from being the home of one of the most prominent lawyers in Joliet at the turn of the century, it is also an excellent and very intact Queen Anne style home.

Style: The home Downey home is an excellent example of the Queen Anne style. The style is seen in the asymmetrical massing with the tall tower dominating the south east corner. The style is also seen in the spindle porch which originally wrapped around the side of the house, the cut shingle siding, and steeply pitched roof.

The history: The house at 509 Buell Ave was constructed in 1889 for then up and coming lawyer John W. Downey. It was constructed in a distinctive row of Queen Anne homes perched on the hillside with a stunning view across the Buell Ave ravine.

The home was owed by the Downey family, first John W., and then Bob Downey, until about 1990. Over the years several alterations were made including the addition of an Arts & Crafts front door and sidelights, and the filling in of the west side of the wrap porch. The house was also at some point divided into 2 units.

Around 1990 Kurt and Dana Pflederer purchased the home from the Downey family and started the restoration. It was also at that time that the carriage house, badly damaged by fire, was demolished

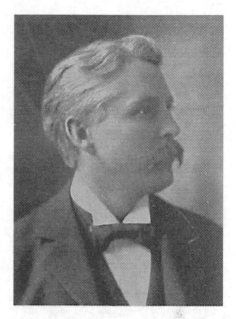

The Downey home was purchased in 2004 by Tom and Jina Dziekan. They absolutely love old houses, and found in this house "everything they ever wanted". While Jina is split on interest in the Architecture and People of the house, Tom is more focused on the story of the original family.

Details: The Downey home is a wonderful Queen Anne and has many special features throughout the home. Among these are several brilliantly colored stained glass windows, hardwood floors, delicately detailed plaster ceilings, and elaborate fireplace with original ceramic glazed tiles.

Around the turn of the century there was a remodeling done and the pocket doors were changed to French Doors, which allowed more light to flow through the house, and the dining room ceiling was redesigned with heavy wood beams. It was also at this time the front door was changed and the side lights added.

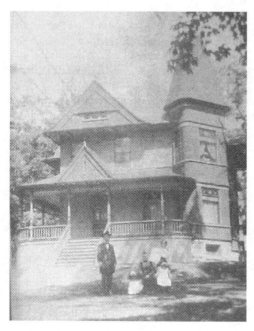

One of the most stunning features though is the assortment of original Gas Electric Lighting throughout the main level of the home. Several fixtures still retain their original Vaseline Glass shades.

The people: John Downey was born in Norman Township in 1860 to John and Mary Downey. He was educated at the Northern Indiana Normal School at Valparaiso IN. Upon completion of normal school, he taught for five years in Grundy County.

In 1885 at 25 years of age, John W. Downey completed the study of law and went into the office of Haley and O'Donnell. In 1890 he started a partnership with Morrill Sprague and finally in 1894 with Eneishia Meers, before setting up his own practice.

33

He started his political career early in life. At age 27 he was nominated for City Attorney by his party. Although he lost in that election, he came back the next election and won and went on to serve others terms.

He was married to Francis Kavanaugh in 1890 and had 6 children, Marie, Harold, Arthur, Donald, Frances and Robert. Robert was the last Downey to live in the home. He remained there until approximately 90 years of age.

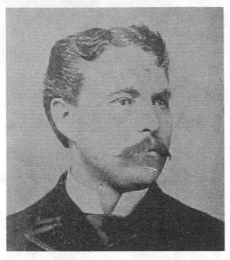

Did you know? The 1910 census of Joliet shows a servant named Eva who lived with the Downey family. The writing is too light to determine her last name.

Illustrations:
509 Buell today, photo, author
John W. Downey, 1897, Joliet Illustrated, courtesy of Joliet Public Library
509 Buell, ca. 1896, courtesy of Thomas and Jina Dziekan
John W. Downey, ca. 1890, Joliet Sketches, courtesy of Jay Riemer

The Clinton E.B. Cutler House, 614 Buell Ave

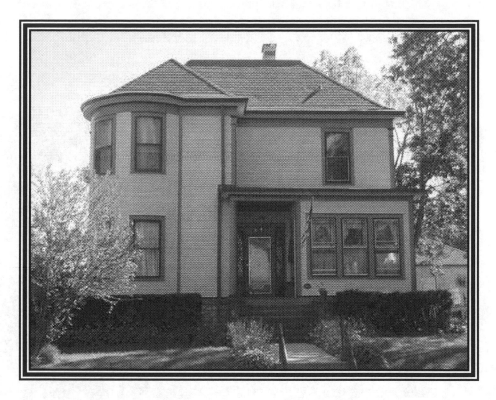

Why it's important: Clinton Cutler was on of the most prominent political figures in Joliet and Will County in the early years of the 20th century.

Style: The Cutler home is a transition home from the Queen Anne to the Colonial Revival. The Queen Anne is seen in the tower dominating the north east corner and protruding bay witch supports the staircase. The Colonial Revival features include the engaged or built-in columns on the corner of the house, and the single entry door with sidelights.

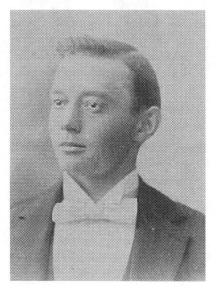

The history: C.E.B. Cutler home was constructed around 1901. Mr. Cutler actually lived further west in the same area in the year preceding the construction of his home on Buell. Although the architect is unknown, the contractor for the house was William Bryant. Mr. Bryant was also the contractor for many other structures in Joliet including the Snapp home at Fourth and Richards and the Rachel Flats on Jefferson St…

Brian and Shawna Watkins are the current owners of the Cutler home. Brian had grown up in old homes, and both of them loved the big old Victorians. A few years ago they randomly drove through the Cathedral area and discovered the unique and beautiful architecture there. In 2003 they purchased the home

Details: The Cutler house is an interesting transition from the fancy formal Victorians style to the

simpler and more refined Edwardian Era homes. The interior is simple, it originally had an "L" shaped entry halls which lead to a beautiful oak staircase, and there was also a corner fireplace at the bend. Sometime in themed 20th century, the front parlor and hall were opened to create a large open room. The house was also at that time converted to a two unit. In an interesting variation away from the typical up and down division, the Cutler house was divided into side by side halves. The house was unified once again by previous owners and a replacement mantel was again installed in the corner of the entry hall area.

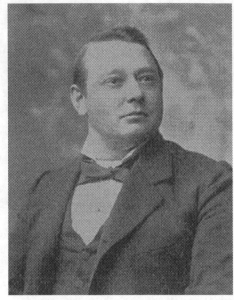

The people: Clinton E.B. Cutler was born in Homer, Will County in 1871. He attended district schools in the winters and worked on the family farm in the summers. He graduated from Joliet schools in the early 1890s. In 1893 he decided to enter the law practice, and studied with Donahoe & McNaughton. He began a practice after graduating from Northern Indiana Law School in 1895. He was married in 1897 to Miss Maud Emmet.

In 1897 Mr. Cutler was appointed to fill the position of Supervisor of Joliet Township. At the time he was 26 years old and the youngest person to hold that position. In 1898 he was nominated on the Democratic ticket for that position, and was elected that year for a 2 year term. He was widely recognized as the leader of the younger element of the Democratic Party in the area. One of his most interesting contributions was the first introduction that all work done on county buildings or under county control should be done by union citizen labor. Although the measure failed it showed that he supported the interest of laboring men in his community.

Did you know? At the time the Clinton Cutler house was constructed in 1901, it was the only house on the 600 block of Buell Ave.

Illustrations:
614 Buell today, photo, author
Clinton Cutler, 1897, Joliet Illustrated, courtesy of Joliet Public Library
Clinton Cutler, 1905, Come to Joliet, courtesy Joliet Public Library

The J.C. Adler Jr. home, 618 Buell Ave.

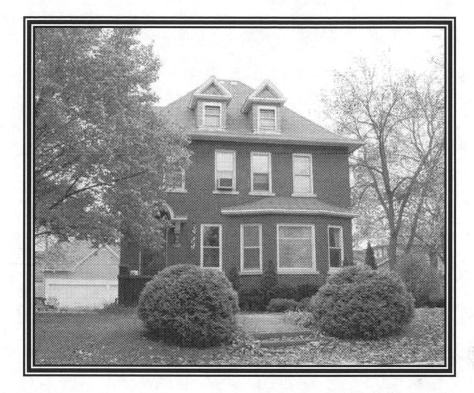

 Why it's important: The J.C. Adler Jr. home is a wonderful simple Colonial Revival home. It is also was the home of one of Joliet prominent business families.

 Style: The Adler home is a 2 and a half story Colonial Revival home. The style is seen in the simple massing with the steep roof and 2 Colonial Dormers. Also of note is the simple bay window an the front and small entry common in the Colonial Revival style.

 The history: The Adler home on Buell is one of the early homes west of Brooks Ave. It was constructed in about 1905 and was preceded by the 2 house to the east and one further up the 600 block. It is one of the largest homes on the block and with the steep front yard holds an imposing view.

The home housed the Adler family for over half a century. During that time the house was split into 2 sections and part of the house was rented.

The J.C. Adler home is currently owned by Rosita Jarquin. Rosita used to work in downtown Chicago and lived in Elgin. When one of her children moved back home she sought a larger home. By chance she saw an advertisement for this home and was quite happy with the ample space for herself and her family who lives with her.

 Details: The J.C. Adler Jr. home is well appointed and very well constructed. The simple brick façade is only broken by the shallow bay window on the front which has a beautiful leaded glass window.

Upon entering the home the split of the house is noticeable with a massive door with leaded glass leading into the downstairs. This vestibule area is enhanced by an Arts & Crafts style stained glass window. The hardware, also original is heavily detailed in this area.

The main rooms of the home have coved ceilings and simple woodwork. The interior still retains may beautiful features, though some areas have been modernized by previous owners.

The people: J.C. Adler Jr. was born in Joliet in 1871. He was brought up in the city and attended the public schools in Joliet. He attended Niagara University, New York for a short time, and then attended Bryant & Stratton's Business College in Chicago.

He left school in 1888 and wet into the employ of Adler Brothers in Joliet. After the dissolution of the firm, he entered into the firm of J.C. Adler & Co. as an employee with his father as Senior Member. In 1892 he became a partner in that company.

The business of J.C. Alder and Co. had it roots back to 1861 when his father founded the company. It was located in a large building on Exchange St. (now Jefferson St.).

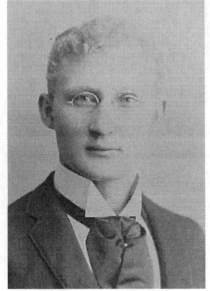

In 1897 Mr. Adler married Elizabeth Young daughter of Henry Young, owner of the Young Building formerly on Jefferson between Chicago and Scott St. The Adler lived with the Young Family until they moved into their new house in 1905. Miss Young's sister who was building manager for the Young Building also resided with them in the house on Buell.

The house left the Adler family only in around 1960. It went through a couple other owners until being purchased by the current owner.

Did you know? The Adler business had its own slaughter house and stock farm one mile from the city on Channahon Road.

Illustrations:
618 Buell today, photo, author
J.C. Adler Jr., 1897, Joliet Illustrated, courtesy of the Joliet Public Library

The Arthur Charles Clement home, 519 Campbell St..

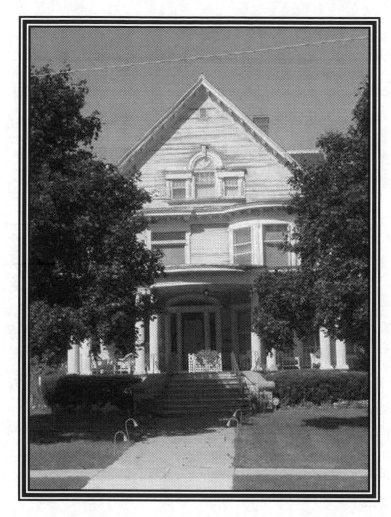

Why it's important: The A.C. Clement home is a fantastic Colonial Revival mansion belonging to one of the founding families of Joliet.

Style: The Clement home is a 2 and a half story Colonial Revival home. The style is seen the heavy use of classical design with engaged Ionic columns on the corners. The steeply pitched roof is accented with Palladian windows as are several of the side dormers. The west side also has a large window with full pediment and free standing columns. The carriage house also matches the main house in design.

The history: Constructed around 1907, the house is built on property owned by A.C.'s father Charles Clement. It was designed in the popular Colonial Revival style. There are several homes in the area that are quite similar, though no architect has been uncovered for them.

The house was lived in by A.C. Clement, then his daughter and her husband. After that the house served for a long time as the Resthaven Retirement home before becoming Blackburn Funeral

Home. After the funeral home moved out the house was sold. During this time it was converted into several related living units.

The Clement home was purchased in 2000 by Diethard Beyer and Kurt Caudill. Over the past 3 years they have done extensive upgrading and restoration to the interior. Among these were the uncovering of inlaid hardwood floors, and the original Arts & Crafts painted walls in the dining room. These stunning paintings are scheduled for restoration soon.

Details: The Clement home is a fantastic Colonial Revival with all the elegant trapping of a home of the period. The full length front porch enters into a vestibule and then into a formal entry hall. A staircase rises to the left and has a newel post that is over 6 feet tall, a recessed bench with original coat hooks, and a stunning scenic stained glass window on the landing.

The living room is outfitted with mahogany woodwork and green tile fireplace mantel. The study has a Tiger maple beamed ceiling and woodwork, the dining room has oak woodwork with wainscoting with a hidden wine dumb waiter inside on of the panels. A door exits off the dining room to a side porch and the door is enhanced with leaded glass windows.

The upstairs has a master bedroom suite with built in armoire, and another bedroom with original Arts & Crafts style tile fireplace mantel. The rear of the second floor has the servants area separated b a door. It is here where the entry to the attic story is. Contrary to many stories, the upper levels of houses in Joliet such as these were for storage or may have had servant's rooms, but no ballroom.

The people: The Clement family has a long history in Joliet. Charles Clement came to Joliet in 1834 from New Hampshire and purchased land from Charles McKee at the corner of Bluff and Jefferson.

He grew in prominence in the new community and became the first city treasurer. He also built a fine Dry goods business. In 1844 he married Cordelia Wilcox. The couple had 2 children, one of

whom was Arthur Charles. The Clement family lived on the fashionable Scott St. though the 1870s before moving to Eastern Ave. Arthur was engaged in the legal profession with Egbert Phelps. He constructed the home on Campbell St at a time when the new fashionable area of Joliet was the Western Ave. area.

In 1897 A.C. Clement formed a business partnership with his brother in law Samuel D. Chaney. This partnership lasted until 1903. At that time he went into business idependantly. He also constructed the Clement Block at the corner of Jeferson and Ottawa. Among other clubs and organizations, Mr. Clement was president of Silver Cross Hospital at the time of the construction of the old stone structure.

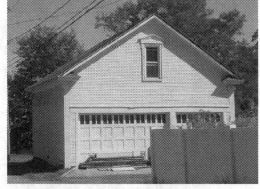

He was married in New York to Miss Georgia Smith, and they had two children, Charles A. and Laura. Charles went into the Real Estate Proffesion.

Did you know? In many Victorian and Edwardian homes there was and entrance from the dining room to the outside In most cases they lead to formal porches and occasionally to formal gardens or yards.

Illustrations:
519 Campbell today, photo, author
519 Campbell, 1916 Artworks of Joliet, courtesy of Andrea Magosky
519 Campbell Carriage house today, photo, author

The Fred Walsh home, 606 Campbell St

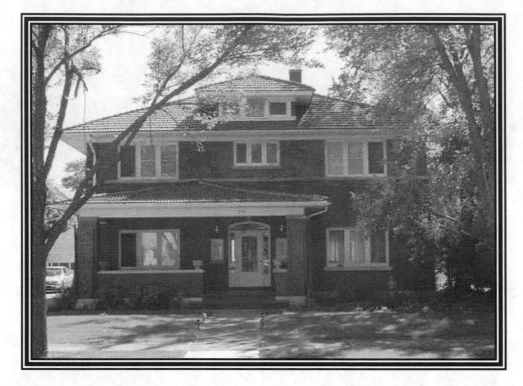

Why it's important: The Walsh home is an excellent example of early 20th century Prairie Style design by Joliet architect Rudolph Hoen. It was also the home of one of the founders of the Will County Board or Realtors, now the Three Rivers Board of Realtors.

Style: The Walsh home is a classic Prairie style structure. The style is seen mostly in the long low lines of the home. This look is emphasized by a simple stone band at the bottom of the windows on the second floor which elongates the visual effect. The style is also seen in the green glazed French Tile roof, and the triple window arrangement.

The history: The Walsh home was constructed in 1920 on property adjoining the home of Mrs. Walsh's parents at 608 Campbell. The home was designed by local architect Rudolph Hoen. The Walsh family would live here for about 10 years, at that time the family became too large for the 3 bedroom house. The house was sold and would go through several hands before being purchased by the Schiek family in the late 1960s. They would own the home all they way through 2004.

The Walsh home was sold to the author of this book in 2004. A restoration to the home has begun to return many of the fine features of this home back to the original state.

Details: The Walsh home is very Prairie inspired on the exterior, with long low lines emphasized by the low green tile roof. However there is a very Colonial Revival undertone in the design as well. This is seen in the entry which has a typical transom and sidelight motif common to the Colonial Revival.

This theme is carried to the interior as well. Instead of the traditional Oak Woodwork and heavy Arts & Crafts styling common in Prairie design, here we see painted woodwork with Mahogany stained doors. Instead of simple brass hardware, lavish Rococo Brass hardware is evident in the formal areas, and crystal doorknobs are throughout the rest of the house.

The floor plan is also typical colonial Revival with the long living room to one side of a central hall and the dining room and kitchen on the other. One of the nicest parts of the house is the expansive master bedroom which takes the entire west end of the second floor and has a built in window seat overlooking Campbell St.

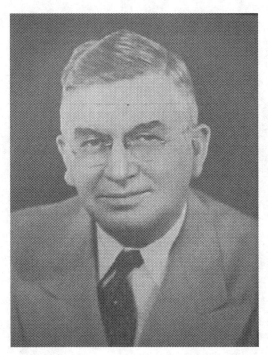

The people: Fred J. Walsh was born in 1882 in Terre Haute Indiana. His father John came to Joliet from Ireland and later moved to Terre Haute. Fred Walsh attended public schools in Terre Haute, and graduated from Joliet High school in 1901. He returned to Terre Haute to enter the banking business and the started in the Real Estate business.

Around 1910 Fred Walsh returned to Joliet and constructed a home at the north-west corner of Wheeler and West Park Front. It was while working in Joliet he married his wife, an employee, in 1918. It was for his new wife that he constructed a home next to her parents on Campbell St. The family would live in the Campbell St. home for 10 years until the family became too large. They then moved to the old Buchanan home in West Park (demolished for Interstate 80). After several years in that home they moved to Evanston IL.

He served many positions including 4th President of the Will County Board of Realtors in 1926, 27, & 28, and as president of both the Planning Commission and the Chamber of Commerce.

Did you know? In 1930 Mrs. Walsh received a new 7 seat Cadillac from her husband. As an avid golfer, Mrs. Walsh was driving on an outing with several lady friends when the car overturned. Fortunately no fatalities were reported.

Illustrations:
606 Campbell today, photo, author
Fred Walsh, ca. 1927, courtesy of the Three Rivers Association of Realtors

The Charles Wallace House, 709 Campbell St

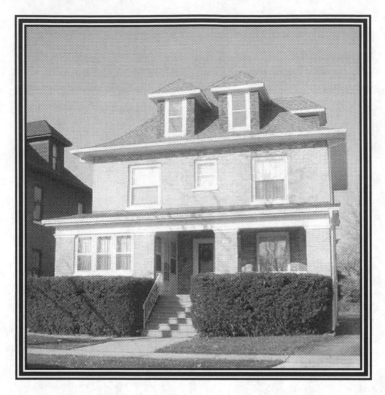

 Why it's important: Charles Wallace was a prominent architect in Joliet and the surrounding Chicago area. He is best known for designing St Patrick's Church and the old St Raymond's church in Joliet

 Style: The Charles Wallace house is a traditional American Four-Square. This style is based on form rather than decoration. A typical four-square house has four even, or close to even walls. The massing of the structure is usually simple with occasional other stylistic touches.

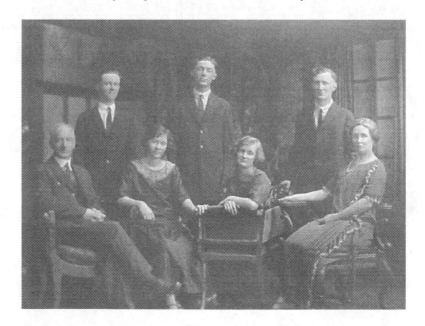

The history: In around 1896 Charles Wallace constructed a building on Washington Street in downtown Joliet. He resided there until the plans were made to elevate the train tracks. The property on Washington St. was sold around 1907, and Charles Wallace designed his home on Campbell St.

When he built his house at 709, he also constructed an almost twin next door for his mother and architect sister Elizabeth Wallace.

The Charles Wallace home is owned by Ray and Sharon Skaggs. They purchased the house in the 1970s when they were first married. They were taken with the beautiful design of the house. They have been carefully working on the house and were very pleased to be contacted by the granddaughter of Mr. Wallace Mary Wallace Adams.

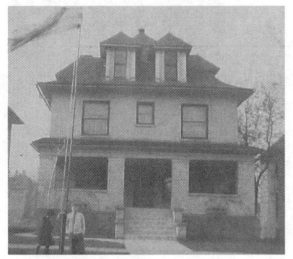

Details: The Wallace home is a simple grey-buff brick structure with simple flat surfaces. The main features of the exterior are the full front porch and steeply pitched roof with a pair of dormers.

The interior has some wonderful features. The house in entered through a small vestibule which has a coat rack original to the house. Once inside there are Oak Columns to the right which lead into the living room, and a pocket door which leads to the study.

Some of the wonderful details are the heavy Gothic Ecclesiastical hardware on the doors, and the curved cove ceilings in the main rooms. Another unique feature is the staircase which is nestled into a side alcove. There is no grand sweeping staircase seen from the entry. This is a design element Wallace would use in other homes.

Some other interesting features are the varied light fixtures which many are originals to the house, either from construction, or early remodeling. There is a carriage house to the rear of the property which has lost its second floor over the years. Charles used the upstairs of this structure for many years as an extra studio.

The people: Charles Wallace was born and raised in Joliet. He graduated in 1889 from Joliet Township High School. In 1896 he married Julia Ellen Mahoney. It was this time that he set up his architectural practice in Joliet. They first lived on Cass St with Julia's family, then on Illinois St, then to the Wallace Flats on Washington St.

In 1907 the family moved to Campbell St. it was while he lived here that his greatest work was done. During that time he designed St. Patrick's church and school, St Raymond's church and school, St Joseph's school, Fire Station on Washington St., Hibernian Hall on Cass St, plus many other commissions in Joliet and across the Chicago area. His residential designs include the LeSage

house a 619 Western Ave. and the Comerford house at 718 Western Ave along with his home on Campbell.

Mr. Wallace lived in the home until his death in 1949. For the last 10 years of his life he lived in the dining room as his health was failing over those years. The family owned the house until 1956 when Julia died. The house was at that time sold out of the family.

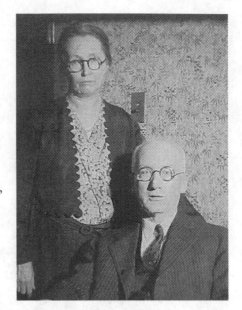

It is interesting to note that Mr. Wallace was known for his church and church school design. Also interesting is one son, Charles Jr. became a priest and one daughter became a nun. Charles Wallace's sister Elizabeth was an architect. Little is know of her or anything about her work.

<u>Did you know?</u> Elizabeth Wallace was the first female architect in Joliet.

Illustrations:
709 Campbell today, photo, author
Wallace family (Charles seated left), ca. 1920s, courtesy of Mary Wallace Adams & Ray and Sharon Skaggs
Wallace house, date unknown, courtesy of Mary Wallace Adams & Ray and Sharon Skaggs
Charles and Julia Wallace, ca. 1940, courtesy of Mary Wallace Adams & Ray and Sharon Skaggs

The John Lyons house, 521 Oneida St.

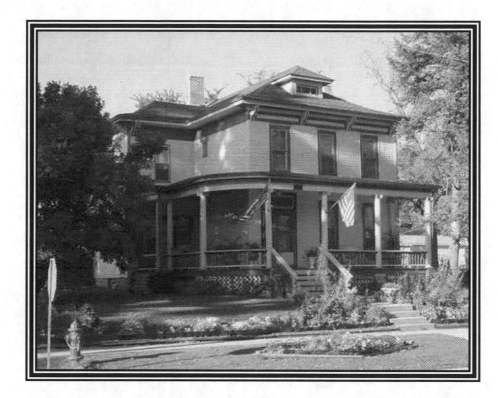

Why it's important: The John Lyon house is a beautiful 1880s home, built for the founder of one of Joliet's oldest lumber companies.

Style: The Lyons house is constructed in the Italianate style. This is seen in the heavy brackets around the roofline. The current sweeping front porch was added around the turn of the century and is in the Classical Revival style.

The history: Constructed around 1887 for a cost of approximately $3000.00, the Lyons house is a well appointed Victorian home. When it was built on Oneida St, this was one of the focal points of the street. The house was constructed in the very fashionable Italianate style with low hip roof and small porches. The house had double doors typical for this period and style.

Around the turn of the century, the roof pitch was raised to its current height and the front dormer was added. The large wrap porch was also added at this time. The entry was also changes from double doors to single and a stunning leaded transom was added over the door.

During the 20th century the house was divided into 2 units, one up and one down. This format was in place until the current owner who is working to reunite the house to its original floor plan.

Jerry Haseman purchased the home in 1999. The home was two units when he purchased it and he is planning the reunification of the house to the original plan. He has already done extensive work restoring the porch, and removing a sun porch which had been added to the home over the porch on the side.

It is interesting to note that an 1887 description of the home states is was stark white with green shutters. Without knowing this, Mr. Haseman chose a white with green paint scheme for the house.

Details: The Lyons house has all the comforts of a Mid-Victorian home. Many stunning features still survive in the home, from the low curving staircase, to the elegantly detailed Eastlake style Marble Fireplace in the front room. Most of the woodwork is original to the home, though some of the first floor was altered for the division into apartments. The dining room hosts a massive built in cabinet and beamed ceiling which dates to the remodeling period.

The upstairs has an almost completely intact plan with original woodwork and a servant's area separated by a doorway which also has a back staircase which would have connected to the kitchen below.

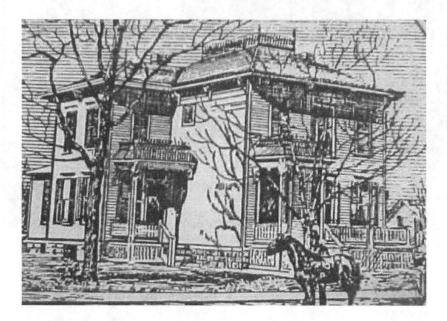

The people: John Lyons was born May 11th 1834 in Longford Ireland. In 1849 he came to New York, and in 1855 he came to Joliet. He entered the contracting and building trade upon his arrival and would continue in this business until 1875 when he formed a partnership of Patterson and Lyons and built a lumber yard on south Bluff St.

In 1881 Mr. Lyons bought out his partner and moved the business to the corner of Clinton and Desplaines. The Lyons' had four children, 3 boys and 1 girl. They lived in the house through the 19th century and into the 20th.

Did you know? Though the Lyons lumber company was sold out of the family in the 1940s, it still survives today on East Washington St.

Illustrations:
521 Oneida today, photo, author
521 Oneida, 1887, Joliet News supplement, August 18th, collection of author

The F.S. Allen home, 608 Morgan St.

Why it's important: The Allen home is an excellent example of Richardsonian Romanesque architecture, as well as the home of one of Joliet's great architects.

Style: The F.S. Allen home is a very strong and straight forward example of the heavy Richardsonian Romanesque. This is seen in the heavy stonework, the massive and imposing Romanesque arch on the front of the house, and the heavy granite boulder foundation.

The history: The Allen estate was constructed in 1887. Mr. Allen purchased 6 adjacent lots in the Stevens & Munroe subdivision and constructed his home and carriage house on the site with a long curving entrance and terraced yards.

The home according to court records was completed in September of 1887. The contractor for the home was killed in the collapse during construction on the Barber Building and an unpaid bill for the house construction was filed in court

specifying the date of completion. Also on the site were constructed a carriage house (burned down), and a greenhouse (demolished).

Mrs. Mary Allen died in 1895. It was after that, that a servants house was constructed facing Dewey (then Stevens) St. In 1898 Mr. Allen remarried and the house was extended to accommodate a library and two new bedrooms. This addition filled in the open stone porch and hung three rooms off the back of the house.

The Allen family moved from Joliet in 1905 and the home was sold to Mr. Blackhall the owner of the Street Car line and builder of Dellwood Park. It was while he owned the house that Morgan Street was cut down to accommodate the street car which ended at Mr. Blackhall's house. The home was then sold through a series of owners until the 1960s when it was purchased by the current owners.

The Allen home is owned by Patrick and Andrea Magosky. They purchased the home in 1968 and have worked extensively researching Mr. Allen and his family. Over the years they have talked with and met F.S. Allen's daughter Nancy (now deceased) and several grandchildren.

Details: The F.S. Allen home is a wonderful example of the Richardsonian Romanesque. It is almost as though Mr. Allen was paying tribute to Richardson who died in late 1886. The house has one of the largest and best Richardsonian arches in Joliet. This arch springs into a curve much lower than most and covers a large expanse which leads to the entry alcove.

A marble floor and large oak door welcomes you into the alcove, once in the house, there are oak floor throughout the first floor. The main rooms are very open and the entry hall seems to just mesh with the Parlor and Study. All of these rooms have Black Walnut woodwork, the Dining room off to the right is decorated with Golden Oak. Although all of the original mantels have long since been removed and many ornate features such as fret work and embossed ceilings are now gone, there are still many interesting features of the home. Among these are the heavy molded plaster cornice in the Study, and small beveled window on the front porch, the only use of which is to see who is approaching the house from the hostess seat at the dining room table.

The second mater bedroom still maintains its original Birdseye Maple mantel and woodwork. The home also has several light fixtures installed in the 1898 remodeling.

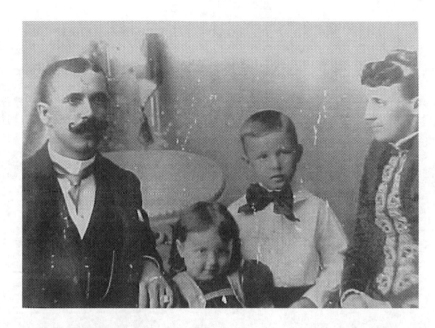

The people: Frank Shaver Allen was born in Galesburg IL in 1860. Throughout his professional life he would simply use his 2 initials. He studied architecture in Chicago, and then completed his studies at the Ecole Des Beaux Arts in Paris. He married Mary Hendrie of Chicago in 1885. She worked at her father's clock shop around the corner from Mr. Allen's Chicago office. Shortly after they were married, the Allen's moved to Streator IL where he designed a house and several other buildings. He was brought to Joliet in 1886 when his design was chosen for Christ Episcopal Church.

Within the next year Mr. Allen designed his home, the old Broadway School, and the Barber Building. He would go on to design the Haley home, Krakar home, & Joliet Central, as well as the Fish home, Barber home, and Sheridan School all demolished. During the years of 1887 until 1905 he also design Port Washington High School in WI, Sioux City High School in IA, and schools in Michigan and Indiana as well as the Daley home in Dallas TX.

The Allen's moved to Altadena CA in 1905 and lived there until their divorce in the 1920s. Afterwards Mr. Allen retired from architecture and ran a music store and traveled. In California Mr. Allen designed schools in San Jose, San Diego, Santa Barbara, San Pedro and Duarte to name a few.

Did you know? At the time of Mr. Allen's death he had an extensive art, decorative architecture, and Egyptian collection. Among many of his items included a clock from the 1893 Worlds Fair and a teapot that was a personal gift from Queen Marguerite of Italy.

Illustrations:
608 Morgan today, photo, author
608 Morgan, 1895 Artworks of Joliet, courtesy of Joliet Historical Museum
F.S. Allen in Germany, 1922, collection of author
F.S. Allen, Mrs. Mary Allen and children Fred and Ida May, ca 1887, courtesy of Nancy Allen Wolf & Patrick and Andrea Magosky

The Fred Sehring home, 310 Bridge Street

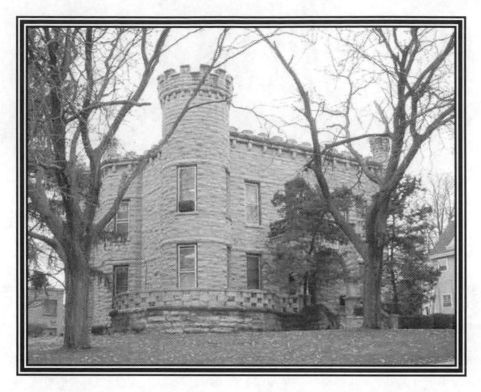

Why it's important: The Fred Sehring home is one of the fine late 19th century stone homes built in Joliet. It was home to a master brewer, and designed by a well known local architect.

Style: The Sehring home or Castle as it is known today was built in the Gothic style with a Romanesque arch in front. The Gothic style started in America during the Romantic period of architecture in the 1860s. The heavy rusticated stone, Romanesque arch, and crenellated parapet all are parts of this style that were popular in the 1880s when this house was built.

The history: The Sehring home is the center piece of what is today known as Sehring Hill. The house was constructed in the 1880s from the designs of local architect Hugo Boehme. Mr. Boehme

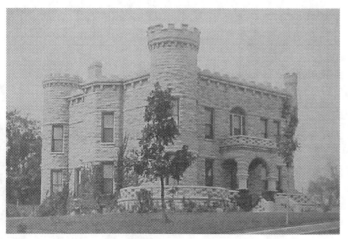

also went on to design the other 3 homes that would be built atop the hill, two for Mr. Sehring's sons, and one for his daughter and son in law.

Mr. Boehme did a lot of work for the German community in Joliet during the late 19th and early 20th centuries. His design of the Fred Sehring home is one of his most creative ones.

The Fred Sehring home today is used as part of the Chancery Office for the

Diocese of Joliet. The home is currently offices, and although not used for its original purpose, still maintains much of its original splendor.

Details: The Sehring home is surrounded by a stone patio which simulates a moat. In the center of this façade there is a small porch which covers the massive oak doors of the entry. There is also a Victorian cast iron Urn in the front yard which is original to the home.

Upon entering the home, there is a small vestibule with another set of double doors leading to a wide central hall. A staircase rises up though the hall and the formal rooms are placed on either side. The home is decorated with beautiful oak woodwork.

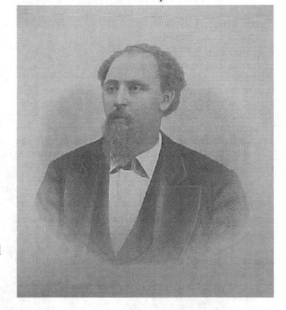

The library still has its built in bookcases and the dining room is still enhanced with oak paneled wainscoting. The center of the second floor has a door which enters out to the top of the porch. This is enhanced with stained glass sidelights and transom.

The people: Fred Sehring was born in Langden, Dukedom of Hesse-Darmstadt, Germany in 1834. In 1847, he came to the Unite States with his parents to Frankfort Township where they engaged in farming. 1854 saw the family move again, this time to Joliet to set up a Hotel.

Fred Sehring served many positions in Joliet. In 1860, he was appointed deputy clerk in the recorders office, and in 1863, he was elected county treasurer. Upon retiring from office in 1867 he purchased an interest in the brewing firm of Joseph Braun & Co.

Upon the death of Mr. Braun in 1870 Mr. Sehring took control of the business and renamed it Columbia Brewery. As the business grew Mr. Sehring made a change, and in 1883, he incorporated the Fred Sehring Brewing Company with himself as President, son Henry as Vice President, son in law Henry Piepenbrink Secretary and Treasurer, and son Louis as Superintendent.

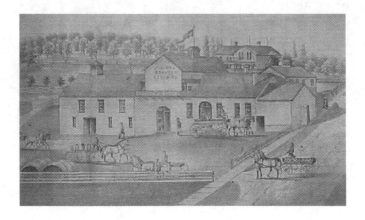

Fred Sehring also served on the City Council starting in 1874 through 1882. In 1874 he also ran for state senate against A.O. Marshall and C. Frazier. The election was close and showed Mr. Marshall winning by a small margin. Mr. Sehring contested the election and it was found that Mr. Marshall had 140 illegal votes, but Mr. Granger's supporters put their support to Marshall who was awarded the election.

Mr. Sehring died in 1892. It has been noted in local histories that his wife was quite a prominent figure in the period also. She assisted in the building of the business as well as being heavily involved in many charities in Joliet.

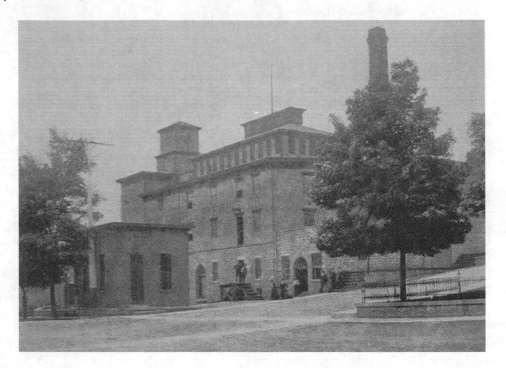

Did you know? The Sehring family had a unique dining room table in the home which was round, and when expanded stayed round through a cleaver series of special pie wedge leafs.

Illustrations:
310 Bridge today, photo, author
310 Bridge, 1895 Artworks of Joliet, courtesy of the Joliet Historical Museum
Fred Sehring, 1905, Come to Joliet, courtesy of the Joliet Public Library
Columbia Brewery Company, 1873 Atlas of Will County, collection of author
Fred Sehring Brewery, 1905, Come to Joliet, courtesy of the Joliet Public Library

The Benjamin J. Benson house, 406 North Raynor Ave.

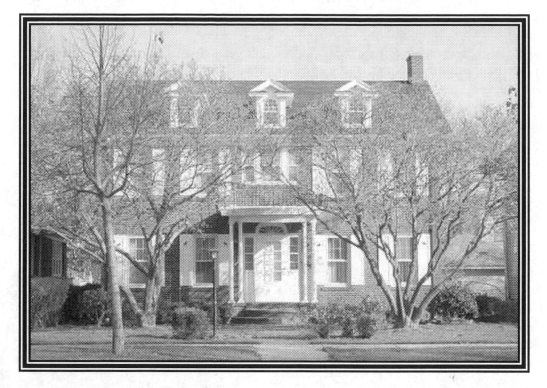

<u>Why it's important</u>: The Benson house is notable as an excellent example of the Colonial Revival Style.

<u>Style</u>: The Benson house is one of the finest pure Colonial Revival style homes in Joliet. The style is seen clearly in the symmetrical façade with central door. The entry has a single door with a fan light over head and sidelights.

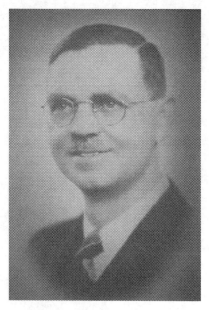

The classic Colonial Revival is seen again in the end gables with curved attic windows. The roof also has the traditional three dormers across the front. The small enry porch originally had a wooden railing surrounding the top, this was replaced some time ago with iron.

<u>The history</u>: Built in 1928, the Benson home was one of the fine homes constructed in the Raub subdivision. The Raub home was located at the corner of Raynor and Glenwood (now demolished).

Built in the Colonial Revival style which had taken hold as the premier housing style of the period, the Benson home has been a notable for the presence on Raynor Ave. since its construction.

The Benson home was purchased in 1975 by Tom and Marianne

Manley. They had grown up in the area and were looking for a house when this one came on the market. They looked at the house right when it went on the market and Tom says they purchased it on the spot.

Details: The Benson home reflects the Colonial Revival as well on the interior as it does on the exterior. Upon entering the home you go through a small vestibule with a patterned tile floor. Once inside there is a central hall with a simple staircase with a curved newel post.

The hall is flanked by the formal rooms. On the south side is the living room which has a wood burning fireplace and extends the depth of the house. Across the hall is the dining room. All of the formal rooms have simple colonial woodwork and decorative cove molding at the ceiling.

The upstairs has a long central all and 4 bedrooms. The woodwork is painted with deep colored natural wood doors. A door in the hall leads to a full attic. To the rear of the house is a newer addition added by the Manley family. This addition carries all of the original details onto the room.

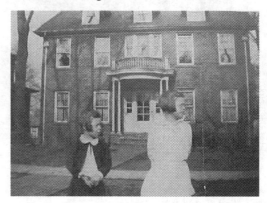

The people: The home at 406 Raynor Ave. was constructed in 1928 by Benjamin J. Benson who was a salesman and later manager of Oliver Realty Company. Mr. Benson also served as president of the Will County Board of Realtors in the 1930s. He and his family lived in the home until 1935 when it was sold to James W. Faulkner. A lawyer with the firm of Faulkner and Nicholson, he would own the home for over 20 years. The home then passed to the Konrad family, and then to the current owners

Did you know? The shutters with the cut in flag design are original to the house. These shutters have become a landmark on Raynor Ave.

Illustration:
406 N. Raynor today, photo, author
Benjamin Benson, ca. 1930, courtesy of the Three Rivers Association of Realtors
406 N. Raynor with the Benson girls in front, ca. 1930, courtesy of Lois Benson Jensen

The Flat building, 700 N. Raynor Ave

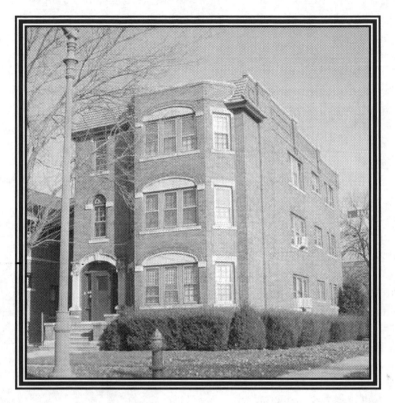

Why it's important: The Flat building at 700 Raynor was the longest residence for Gerlach Barklow artist Adelaide Hiebel. It is also an excellent example of an early 20th century flat building.

Style: 700 N. Raynor is a wonderful modified Colonial Revival building. The style is seen in the Neo-Classical treatment of the entry on the main façade, and elongated oval panels above the windows. The structure deviates from the Colonial feel with the use of the Green clay tile roof.

The history: The Flat building at the corner of Raynor and Mason was constructed in the 1920s and epitomized the new apartment living becoming so popular in the early 20th century. The three story structure allowed ample units on each level. Many duplex and 3 flats would begin to be constructed along Raynor Avenue in the 1920s and 30s.

The Flat building at 700 Raynor Ave. is still a very well maintained 3 flat residential structure.

Details: The flats on Raynor Ave are a wonderful example of the blending of architectural styles to create a new look for a new style of building. Some of the fine details include the delicate Fan Window over the front entry. This is a very traditional Colonial Revival feature. This detail is lightly reflected again in the elongated panels over the main windows incised into the stone.

The building has the original 9 pane over 9 pane windows which again reflect the Colonial Revival movement. Another fine feature is the brick detail in the parapets atop the front bay and along the side. The building is topped with a beautiful Green Tile roof which was a very common decorative element in multi unit buildings during this period.

The people: The flat building at 700 Raynor was the long time home of one of the finest Gerlach Barklow artist Adelaide Hiebel. Ms. Hiebel was born in Sun Prairie, Wisconsin and came to Illinois to study art at the Art Institute of Chicago. It was there that she met one special teacher who would be come her mentor, that was Zula Kenyon.

Around 1918 Adelaide came to Joliet to work in the Gerlach Barklow Art Calendar factory. Her style was extremely similar to that of her mentor Kenyon. She originally had her studio at the top of the original Gerlach building on Washington St, but soon convinced the owners to let her set up her own studio at home.

Her first home in Joliet was on John St. and was where she lived with her husband. She was married for an extremely short time to a mobster named Carl who died shortly after their marriage. They were married so short a time in fact that the family does not even know his last name. Adelaide lived in the John St. home until 1930 when she moved to Raynor Ave.

Adelaide Hiebel continued to work for Gerlach Barklow until 1955. During those years she produced approximately 375 to 400 know signed or documented works. Of all of those works, only about 50 originals are documented today. Ms. Hiebel did purchase many of her favorite originals from the company and took them with her when she went to California in 1955 to retire.

In life Adelaide was an eccentric who loved to throw lavish parties and flaunt the money that she made. Top artists for Gerlach Barklow in 1940s are know to have made as much as ten thousand dollars per work. Among many works done by Hiebel were portraits of all of the CEOs of Gerlach Barklow and the famous painting of Lois Delander, Miss America, in her bathing suit.

Adelaide has a brother Ben Hiebel who also worked for Gerlach Barklow as an artist. His style is very similar to that of Adelaide and Kenyon. Adelaide though was very cautious to make sure he never became more famous than she.

<u>Did you know?</u> According to the family of Ms. Hiebel, Adelaide was very into the spiritual movement. She had a sister who died very young, and Adelaide always said her sister was an angel who sat on her shoulder and guided her work.

Illustrations:
700 N. Raynor today, photo, author
Adelaide Hiebel, ca. 1925, courtesy of Tim Smith
Adelaide Hiebel, ca. 1950, courtesy of Ben Hiebel nephew of Adelaide

"Westmoore", the Lewis Moore home, 301 N. Reed St.

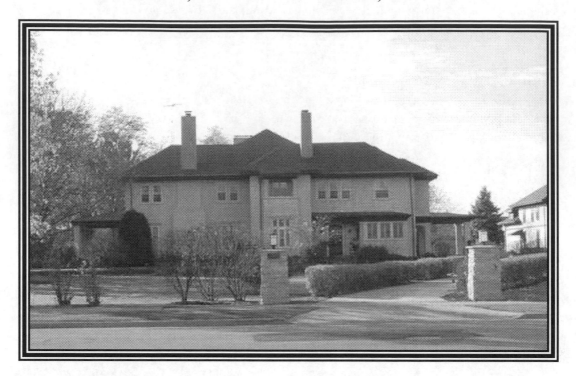

 Why it's important: Westmoore was the estate home of Lewis Moore of Moore Stove works. The home is also a fantastic example of Arts & Crafts design.

 Style: Westmoore is a sprawling Art & Crafts style home built in the English flavor. Much of the design used by architect Charles Birge is reminiscent of the work of Charles Voysey, the leader in Arts and Crafts design in England at the time.

Classic elements of this design are the broad stucco walls with casement and leaded glass windows set in simple openings and squat masonry chimneys piercing through the steep multi-angled roof. Also notable in this style is the unimposing entrance in the front under a low shallow arch, and on the side recessed below the Porte Cacher, or carriage or car entry.

 The history: The plans for Westmoore were drawn by a Chicago architect Charles Birge in about 1897. The Arts & Crafts movement was in wide use world wide, and the English form of the style seems most appropriate for the key visual impact this home would hold over the next century at the end of Western Ave.

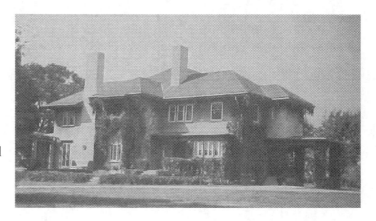

Construction began shortly after and the house would take several years until it was complete. Sources state that the Moore family actually moved into the home around 1905. At the time, the house was the very model

of efficiency and modern convenience. The home was constructed with gas and electric lighting which was the standard for large homes of the period, but some new innovations were in use. Among these was an in house telephone intercom system which linked all the mains rooms of the house (the current owners still have one of the phones), a built in vacuum system with brass outlets in the walls and a doorbell network that singled in the servants area the exact door that was being rung.

In 1936, the house was sold to the Fay family from the widow of Lewis Moore. The Fays would live in the house using it as a base for a very prosperous life. It is known that some important political events took place in the house and on the lawns in the mid-20th century.

The house was again placed on the market after Mr. Fay's death in the late 1960s. In 1973, the Moore house was purchased by Dr. Al and Kay Ray. They were looking for a large home to accommodate their growing family. When they first purchased the house it was condemned by the city and had pages and pages of violations written against it. Al and Kay recalled many stories of cooking on hot plates while the kitchen was being done, and the work of meticulously restoring all the original windows and brass hardware through the house.

 Details: The main house is entered through either the North or East Vestibule which each lead into the large Reception Room. This was a common room arrangement and room naming used in the English Arts & Crafts country homes. The Reception Room has a large staircase nestled into an alcove with a stunning large stained and leaded glass window lighting it. The room is also adorned with a brick fireplace with copper hood with the Moore coat of arms in stone above.

The south end of the house is dominated by the large living room. This room has beamed ceiling, fireplace, bookcases and French doors that walk out to the south porch and to where the east patio was. The dining room off the Living Room and Hall is in the Colonial Revival style which is quite a contrast to the original design and may have been redecorated sometime after the house was built. There are also 2 small office rooms and several service rooms on the main floor.

The second floor has an open central hall and several bedrooms. The master suit is on the south end and has its own dressing room and bathroom. The hall still retains the original brass gas & electric wall sconces. There are also several original gas electric ceiling fixtures on the second floor along with many later fixtures that have been with the house several decades.

There is a full servant area on the second floor as well as a servant's staircase, dumbwaiter, and telephone booth just off the main hall.

The people: Lewis Moore was born in Neenah, Wis., in 1866 to Alexander and Mary Moore. His father was a manufacturer of Stoves and Furnaces. In 1884, on completion of his education, he came to Joliet to enter the business established here by his uncle William Moore in 1870.

Mr. Moore married Mabelle Dillman in 1891, and they had 2 children, Lewis Jr. and Kathryn.

In 1887, the business name was changed to Joliet Stove Works when the firm was taken over by William Moore Jr. and Lewis Moore together. They continued the family tradition established in 1857. In 1907, on the fiftieth anniversary of the establishment of the Moore stove making partnership, it was decided to honor the founders by changing the name to Moore Brothers Company.

Did you know? The Ray family still has the ground plans for the estate which included several terraces, gardens, and a wisteria arbor extending from the south façade almost to Campbell Street.

Illustrations:
301 N. Reed today, photo, author
301 N. Reed front, ca. 1910, courtesy of Dr. Al & Kay Ray
301 N. Reed south facade, ca. 1910, courtesy of Dr. Al & Kay Ray

The Edwin Porter home, 10 N. Broadway

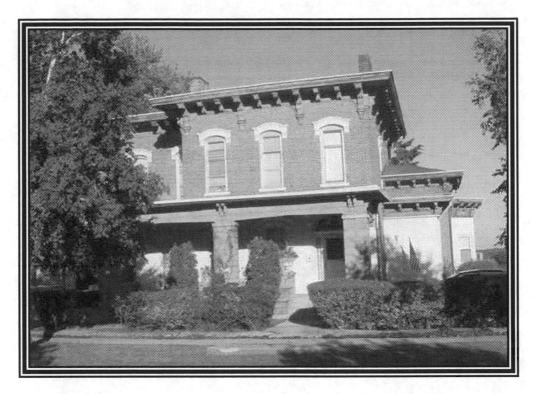

Why it's important: Constructed around 1869, the Porter home is not only a wonderful example of mid-19th century architecture; it is also the home of Brewer, Mayor, Quarry Owner, and Mine Owner.

Style: The E. Porter home is an excellent example of the Italianate style. This style is seen in the very low hipped roof that appears flat upon viewing the home from the street. This is emphasized by the heavy brackets called corbels which decorate the eaves. They almost drip down from the roof in a very elaborate pattern. The style is also seen in the curved top windows with heavy decorative hoods above them. This design is reflected over the front door also.

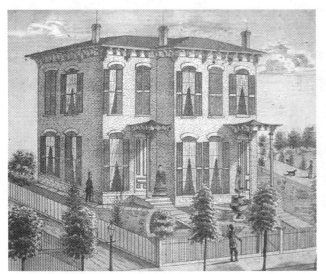

The history: The Edwin Porter home was constructed in around 1869. The home bear the same basic form with only the addition of the massive front porch which was probably added some time around the turn of the century. The 1873 engraving shows the original 2 small front porches. The 1 story bay window on the south side of the house was added some time after the main house also.

The home still maintains many of its original stained glass and leaded glass windows. The first floor of the home on the interior was remodeled around the time the front porch was added, and has superb oak woodwork with massive columns separating the double parlors. There are still three original marble fireplaces on the first floor. The rear of the house overlooks the bluffs from a long original rear porch.

The Porter home was purchased in 1986 by Gary and Sylvia Courtney. They moved from a tri-level in Kankakee to Joliet when Gary was transferred. They had never though about living in old houses until they had the opportunity to live in a Grand Old Mansion. When they purchased the home, many ceilings were dropped. They set about restoring the home, and even found original turn of the century light fixtures simply left above the dropped ceilings.

Details: The home still maintains many of its original stained glass and leaded glass windows. One of the finest is the curve topped window above the front door. The first floor of the home on the interior was remodeled around the time the front porch was added, and has superb oak woodwork with massive columns separating the double parlors and very wide oak cove molding. There are still three original marble fireplaces on the first floor. The rear of the house overlooks the bluffs from a long original rear porch

The people: Edwin Porter was born in Medina County Ohio in 1828. He was the son of a veteran on the War of 1812 and a grandson of a veteran of the Revolutionary War. He lived in Ohio through the early part of his life, and married Almena Curtis while living in Cleveland. In 1856 he moved to Joliet and entered into the Malting and Brewing business. The business was very profitable and allowed him to build his grand home in 1869. Mr. Porter was elected mayor in 1864,1865, 1871, 1879, 1881, and 1883 serving a total of 11 years in office, the mayor to serve

the most terms in the 19th century Joliet. Aside from brewing, he owned the E. Porter & Sons Stone Co. established in 1883, and the Gold King Mine in Cripple Creek Colorado purchased in 1895. The Porter family is buried in one of the few mausoleums in Oakwood Cemetery.

Did you know? The Porter Brewery on Bluff St. was located just below the home. The brewery was supplied

water from 2 natural artesian wells which provided what was claimed to e the best water for brewing. At the height of the Brewery it was on of the largest producers in Illinois.

Illustrations:
10 N. Broadway today, photo, author
10 N. Broadway, 1873 Atlas of Will County, collection of author
Porter Eagle Brewery, 1873 Atlas of Will County, collection of author
E. Porter Brewery, 1905, Come to Joliet, courtesy of the Joliet Public Library

The Edmund Wilcox home, 101 N. Broadway

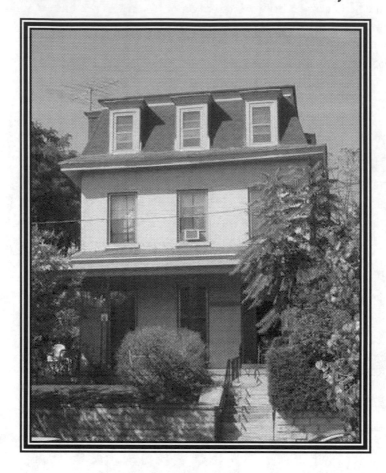

<u>Why it's important:</u> The Wilcox home is one the finest early Joliet residences still in existence. It also stands as one of the oldest brick structures in the city of Joliet.

<u>Style:</u> The Edmund Wilcox home was built in the Greek Revival style. This is seen in the long windows on the first floor which go all the way to the floor. Another element of this style is the masterfully handles entry. The single door is separated from the sidelights by small columns which rise through the transom. This is one of the finest handlings of the architectural element in Joliet. The house received an Italianate flavor when the Mansard roof was added in the latter 19th century.

<u>The history:</u> The Wilcox home was constructed around 1855. At the time of its construction, it was one of many prominent homes along Broadway. Men such as J.D. Brown, Frederick Bartleson, W.A. Strong, and George Woodruff lived along the top of the Bluff.

The home was constructed in the Greek Revival style, though no one is sure today how the roof line actually looked. It may have been a front gable, or perhaps a flat top. What we do know is the home was modernized some time in the 1880s when the steep Mansard Roof style became popular in architectural design.

The home would only remain in the Wilcox family until the 1870s when it would start a long line of owners. Various alterations have been made to the home over the years including the remodeling of the front porch and division into apartment, but none of these changes have altered the basic simple beauty of this design. The Wilcox home has gone through many owners in its long life. It is currently used as a multifamily residential property.

Details: The Wilcox home is void of all of the fancy elaborate details one most associates with the Victorian era. However this house was never meant to have such details. The Greek Revival style exercised restraint is design. So the simple details such a flat window hoods, ad the square block form give the house an air of solid stability. The ornamental focus of the house is the entry, which is very finely detailed.

The interior of the house also reflects the Greek Revival austerity. A simple staircase runs up the north side of the house and the formal rooms would have faced the south. Much of the original Greek Revival woodwork remains intact. This woodwork differs from the Italianate in its proportions and simplicity. The trim is also wider at the top creating a cornice effect in the woodwork, very common of the period.

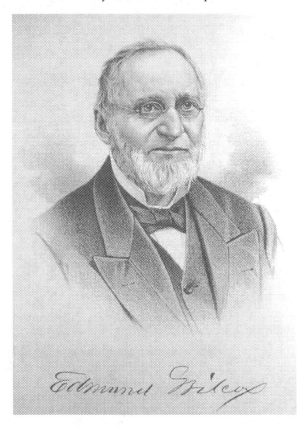

From the exterior you will notice the house becomes gradually smaller as it goes back. These rear extensions housed the service areas of the house including kitchen and servants quarters.

The people: Edmund Wilcox was on of the early settlers in Joliet. He came in 1836 from Onodaga Co. New York. He was 20 when he arrived and was newly graduated from Hamilton College. He joined the mercantile business of Charles Clement, and after two years with the firm bought out the company.

In 1858 Mr. Wilcox sold out his Dry Goods business and became one of the originators of the Joliet Gas-Light Company. Among other business pursuits, he help is obtaining the charter for the Chicago, Rock Island and Pacific Railroad. After several years with the Gas-Light company, Mr. Wilcox retired back into the mercantile business.

On the political side, Mr. Wilcox was the first Alderman of the Third Ward in 1852, a position he would again hold in 1870. In 1854 during the Cholera epidemic, Mr. Wilcox served as mayor pro tem in the absence of the Mayor. Mr. Wilcox was also elected Justice of the peace in1877.

Mr. Wilcox was married to Sarah Green of Washington Co. New York and they had three sons, William, Fred, and Charles. By the 1870s, Edmund and his family had moved from the home on Broadway to a large suburban estate on Marion St, the home is an impressive Italianate which stands on the 500 block of Marion St.

Did you know? The addition of a third story Mansard roof was not uncommon in the 1880s, several other homes including Dr. Raynor's and William Tonner's were also altered in the same way.

Illustration:
101 N. Broadway today, photo, author
Edmund Wilcox, Portrait and Biographical Album of Will County, courtesy of Joliet Public Library

The W.A. Strong house, 111 N. Broadway St

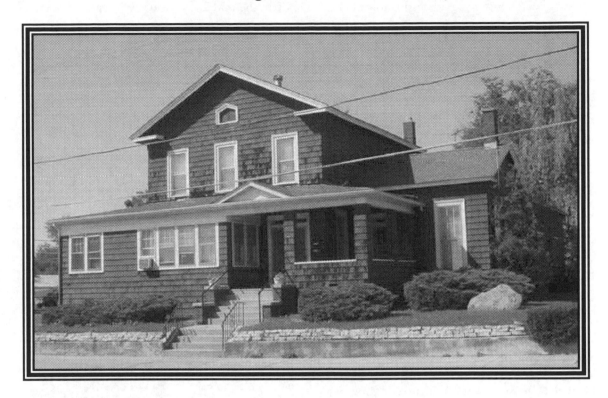

Why it's important: This home was the residence of one of Joliet's mayors and stands as one of the oldest structures in Joliet.

Style: The Strong house is an excellent example of the Greek Revival. The style is seen most clearly in the specific medium low pitch of the gable roof, and the areas at the bottom of the eaves which turn inward which are referred to as returns. The style is also clearly seen in the extremely long windows on the north wing of the house.

The history: The Strong home is believed to have been constructed some time around 1855. That is the period when the Strong name first becomes connected to the property. This date makes the home a contemporary with the Wilcox home located at the other end of the block.

The home would be considered a very spacious grand home for the period. The main block is the defined by the size of the current front second floor and the one story wing to the north. Later additions seem to have been put on in various phases. There is a low long wing which goes back from the north wing which is in the same style as the main house so was perhaps added early.

Further additions include the large sprawling porch, the majority of which has been enclosed. The enclosure was probably done some time in the early 20th century when the current split shingle siding was added over the original clapboard. The rear of the property shows what almost appears to be a separate house attached to the rear of the original house.

The house went through several owners over the years. One of the more interesting uses was when the structure housed the Edward Dames Funeral Home in the mid 20th century. The Strong home survives today as a multi unit residential structure.

Details: The Strong home, although heavily remodeled, still has some excellent Greek Revival details left. The most important is the presence of the returns on the lower eaves. These are just about the most important design elements of the Greek Revival and are all too often lost, thus completely changing the look of the house. The presence of them on the lower wing here helps establish continuity of age and design.

The home also has a wonderful attic window which is designed in a sort of mini style of the house, this is a wonderful feature. The main door to the house is currently double glass doors. These would have probably been added when the home was used as a funeral home, or some time after, as Greek Revival homes almost always have only single doors.

To the rear of the property is the original 1850s Carriage and Horse barn. It is rare in the city of Joliet for out buildings such as this to have survived from this era. The majority of carriage homes which survive today were constructed in the 1880s through 1910s, and are usually designed more to the style of the home. This structure though is classic 1850s simple.

The people: The Honorable William A. Strong was born in Waterloo, Seneca Co., NY in 1828. He made his way to Joliet in 1850 and entered into the hardware business. It was shortly there after that he acquired the property on Broadway.

In 1858 he became a partner in the new Joliet Gas-Light Co., a business which he would be involved with for a great many years. In the 1870s he served as president of the company. He was also engaged in the stone business owning a quarry with Mr. Davidson.

In 1863 he was elected Mayor of Joliet holding the office for one year. He also served several years as an alderman in Joliet. W.A. Strong was married to Charlotte. The couple moved from Broadway in the 1860s when they purchased the old Campbell homestead and land. This property would be divided by Charlotte Strong into the Glenwood Subdivision in the late 1860s.

Did you know? When Edward Dames had his funeral home in this house, brother Fred C. Dames had a funeral home on Joliet Street, and another brother Gerald Dames had a funeral home on South Chicago Street.

Illustrations:
111 N. Broadway today, photo, author
111 N. Broadway carriage house, photo, author

The John D. Paige house, 210 N. Broadway

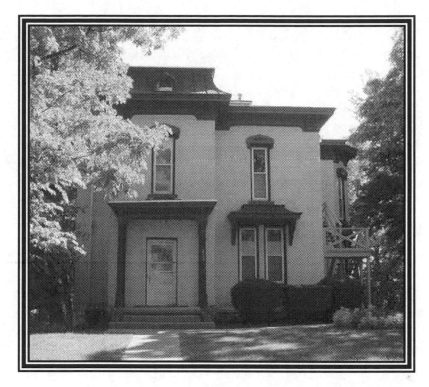

Why it's important: The Paige home is an excellent example of Italianate architecture. It also was the home of Joliet's 19th century Renaissance man.

Style: The J.D. Paige house is constructed in the Italianate style. This is seen in the low hip roof, heavy corbels on the eaves and ornate carved stone window hoods.

The history: The residence at 210 N. Broadway was constructed for Julius C. Williams around 1870. He purchased the land from Sophia Demmond wife of founder Martin Demmond in 1870 and he is shown living on the site in 1872. Julius Williams was a dry goods merchant in Joliet during the 1850s, 60s and 70s. He moved to this house from his previous residence on Eastern Ave.

The home was sold to its most important resident, John D. Paige in around 1880. It was during his residence here that Paige served as mayor of Joliet, among other important offices he would hold.

The home passed from Mr. Paige towards the end of the 19th century and then went through several hands before eventually being divided into apartments. Over the past 50 years several features of the home have disappeared, including

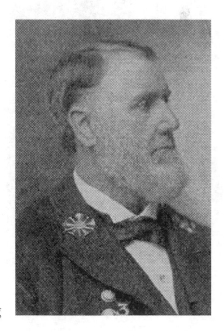

the frame tower which is visible in the period view of the home, and the removal of a full rear porch.

The Julius Williams / John D. Paige home is currently used as a multi-unit housing. Although altered over the years, it still maintains beautiful historic character.

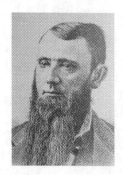

Details: The Williams/Paige home is a wonderful example of the Italianate style. The home was constructed in brick, which was stuccoed in the 20th century. The heavy window hoods remain intact and have fantastic scroll designs in them. The heavy bracketed window hood over the pair of windows on the main façade is very similar to designs in mid 19th century pattern books.

The front porch of the home is the typical small entry porch so common with grand Italianate homes of the mid-19th century in Joliet. The current front door is modern addition which sized the opening down from the original double doors.

One of the most beautiful features of the house is the very small mansard style roof above the entry bay. This has a delicately detailed small arc topped window. This roof area originally was toped by a large frame cupola. The south side of the house is detailed with a 2 story trapezoidal bay, which is a very typical element of the Italianate style.

The people: The home was built for Julius Williams in about 1870. Mr. Williams owned a clothing store on Jefferson St. in 1859 and in 1877 was listed as a commercial agent. Not much else is know of Mr. Williams.

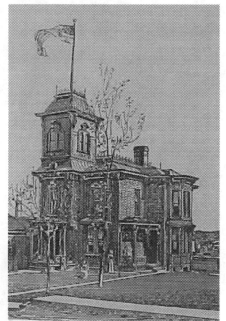

The house is most commonly associated with J.D. Paige. Mr. Paige was born in 1837 in Oneida County. He came with his parents to Wisconsin in 1844 and landed in Joliet in 1857. Shortly after his arrival in Joliet, he purchased a pop and bottling business which he ran until 1884.

Mr. Paige served the public well in a variety of positions. In 1877 he became fire marshal of Joliet. He did a complete overhaul and training of the Department and won the National Fireman's Tournament in 1878. In 1882 he was elected Supervisor for Will County and it was during his time on the board that the new courthouse was planned and constructed.

Mr. Paige would go on to serve as Mayor of Joliet in 1883 and police chief for the city also. He resided in the house through his term as mayor. Mr. Paige was married with what a period publication calls a "large, interesting and useful family of children".

Did you know? When J.D. Paige ran for mayor, he entered a presumed uncontested race the Saturday before the election as an independent candidate, and won the following Tuesday by a 163 vote majority.

Illustrations:

210 N. Broadway today, photo, author

J.D. Paige, 1905, Come to Joliet, courtesy of the Joliet Public Library

J.D. Paige, Will County history 1878, George Woodruff, collection of author

210 N. Broadway, 1887, Joliet News supplement, August 18th, collection of author

The Simon Hausser home, 600 N. Broadway

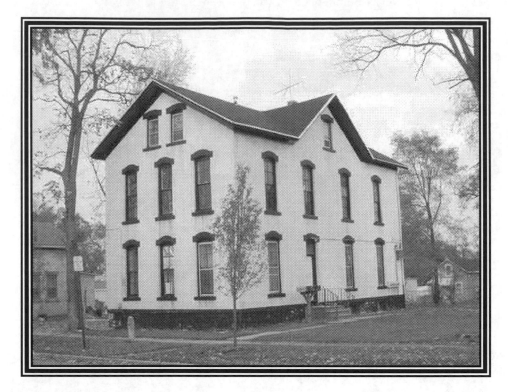

Why it's important: 600 N. Broadway is an excellent German Vernacular home built by local Alderman, Mason, and Quarry Owner Simon Hausser.

Style: The Hausser home can best be described as German Vernacular with heavy Italianate influence. The simple stark massing of the stone house is very common of the early homes built by German immigrants to Joliet. The severity of the house though is relieved by the arch topped windows with heavy stone hoods which reflect the Italianate style.

The history: When Simon Hausser came to Joliet in 1849 he acquired several parcels of land along Broadway from Bridge St to present 602. He first lived in a small structure along Vista Lane while constructing a larger home at 602 Broadway.

During these early years Simon worked as a stone mason and operating a quarry bounded by Stone, Broadway, Bridge, and Bluff Streets. Aside from providing stone for his own structures (there

would be at least four built by Hausser), some of the stone was used for local building such as St. Johns Church, St. Joseph Hospital, and the Old Jefferson St. Bridge.

During the height of his career in 1872 he constructed the large family home at 600 Broadway. By the measurements of the day, this was a very large and impressive home. Even today in comparison to many surrounding structures it still tower above them.

The Quarry was eventually used to the natural boundaries, and other structures would be built within the walls. Among them was the original stone quarry office which still stands just off of Bridge St along an alley.

The Simon Hausser home is now a multi unit residential structure. The quarry has been built in with several structures, but some have been demolished and some of the original stone quarry walls are visible, as well as the Hausser Quarry office structure.

Details: The Simon Hausser home today is distinctive as the large imposing white stucco house on Broadway and Stone, though when constructed it was originally smooth finished stone with ornamental window hoods. A unique feature of the house is that it faces the side rather than the front street. This seems to have been common for Hausser to face his house towards the quarry rather than entering out to a busy street. This is the same format he used for his first house to the north.

The simplicity of the house is also seen in the simple entry door with no surrounding porch. This seems to be typical in the early German homes of Joliet displaying a more sensible and restrained style. Along the street on the west side of the house, the original hitching post still remains. This was used for tying up your horse when visiting.

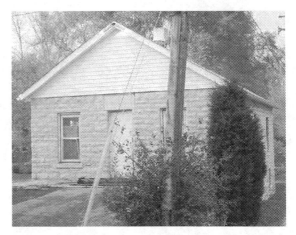

Across Stone St. you could have seen the entire workings of the quarry, as well as several structures that were built by Hausser, or utilized stone from his quarry.

The people: Simon Hausser was born April 13th, 1819 in Rheinpfalz, Wachenheim, Germany. He was the second oldest of 10 children, seven of which came to the United States. He learned the stone mason trade in Germany and immigrated to America in 1847.

After spending time in New York state, and Batavia and Aurora Ill, he came to Joliet in 1849. In the following years as his experience built he was given many prominent commissions in the city. With his brother Jacob he established a quarry on Broadway St in Joliet and operated it until was worked out.

Mr. Hausser was also a very prominent person in the establishing of St Johns Catholic Church. In the public light, he served as the alderman from the third ward many times.

He was married in 1853 to Miss Frances Horn a native of Bavaria. To this union were born 10 children Mary, Theresa, George, Anna, Father Charles, Father Joseph, Carrie, Olive, Simon and Father Henry.

Did you know? Among the structure built by Hausser are, County Jail (demolished), St. Josephs Hospital on Broadway (demolished), and St. Johns Catholic Church.

Illustrations:
600 Broadway today, photo, author
Quarry site along Broadway today, photo, author
Quarry office behind 161 Bridge St today, photo, author

The Marcus Krakar home, 225 N. Hickory St.

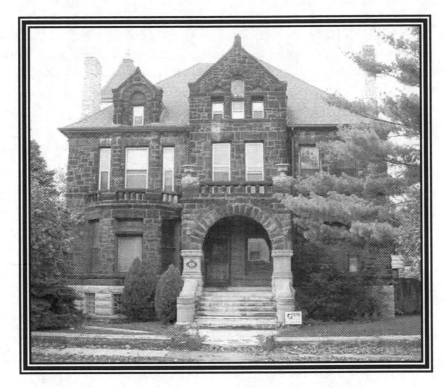

 Why it's important: The Krakar home is important in Joliet for several reasons. First it was designed by nationally known architect F.S. Allen, second it was the home of prominent quarry owner and businessman Marcus Krakar, and finally it is the last surviving brownstone mansion in Joliet.

 Style: The Krakar home is one of the finest existing Richardsonian Romanesque structures in the Joliet area. The style is seen in the massive stone construction of the building. Heavy arches in the Romanesque style are enhanced with foliage carving on the short columns supporting them. There is a massive tower dominating the south side which is topped with a steep pitched roof.

The carriage house to the rear of the main home is also designed in the Romanesque style. It is 2 stories and originally was combined with the carriage house for the R.E. Barber home which stood to the north on Hickory and Western.

The history: The Marcus Krakar home was built in 1895 from the designs of F.S. Allen. Mr. Allen was a prominent architect in Joliet and across the country at this time, and most of his work was in the heavy Richardsonian Romanesque style. The home is built from three different types of stone. The foundation and details of the house are in the local buff colored limestone. The main body of the house is Indiana brownstone from one of Mr. Krakar's quarries in Indiana. Finally there are details in Indiana Bedford stone on the front porch.

The home was built of brownstone instead of completely in local

limestone because Mr. Krakar owned a stone quarry and did not want his house built of the stone he was selling to everyone else.

After the home was lost by descendants in the depression, it became apartments. The division of units was sensitively done, and most of the original interior features were maintained. The home was purchased in the early 1980s by Bob Markley. He has maintained the original elements of the home.

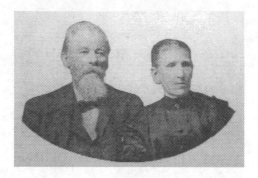

 Details: The Krakar home is one of the finest of the old stone mansions in Joliet surviving today. Built during the height of the quarry industry in Joliet and the Romanesque style, it embodies all the finest workmanship of the period.

Some of the more wonderful aspects of the home are the two tone stone work seen on the side of the home from Western Ave., and the massive two story open stone porch to the rear of the structure. This style of porch is very uncommon in the Joliet area and is only seen on homes designed by Allen, though unfortunately they have been filled in on his other structures such as the Haley Mansion and Mr. Allen's own home.

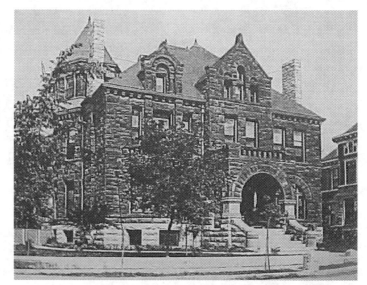

The interior of the home is still a beautiful sight with original fireplaces, woodwork, and operating pocket doors. The house has a central entry hall with an impressive oak staircase. The house is also accented with stained and leaded glass windows.

The people: Marcus Krakar came to Joliet from Liebach Austria in 1860. He settled in Joliet upon his arrival to the United States with his brother Joseph. In October of 1861 Marcus married Jacobina Gorgas of Germany.

Marcus was industrious and started a Tobacco store on Bluff St as the first of many businesses he would own. He built his first home in Joliet across from his brothers on the south-east corner of Virginia and Maple St. His home was destroyed by a fire which prompted the construction of the new home on Hickory. Today his brother's home is still standing.

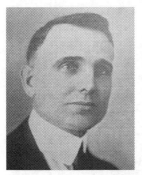

The Krakar's had 14 children including Jacob, who was the Great-Grandfather of the author of this book, Marcus Jr., and daughter Angela. It was Angela who would live with her parents in the home on Hickory Street from the time of construction until it eventually fell out of the hands of the family.

Mr. Krakar aside from owning a stone quarry, also served as alderman for his ward at the turn of the century. He also constructed many fine flat buildings along Western Ave. including the Angela Flats which were named for his daughter and stood at the north-west corner of Western and Hickory. After his death in the early 1920s, Angela and her husband Joseph Zerbes took possession of all the properties which were eventually lost in the bleak years of the depression.

Did you know? Marcus had his own Pullman sleeping car that he would travel in regularly to California to visit his relatives, and Mr. F.S. Allen whom he would remain friends with until his death.

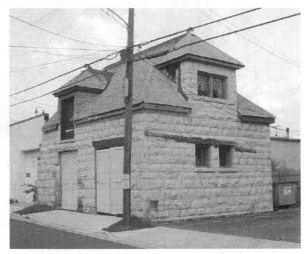

Illustrations:
225 N. Hickory today, photo, author
Marcus Krakar, 1905, Come to Joliet, courtesy of the Joliet Public Library
Mr. and Mrs. Marcus Krakar, 1911 from 50th Anniversary Invitation, collection of author
225 N. Hickory, 1895 Artworks of Joliet, courtesy of the Joliet Historical Museum
Joseph Zerbes, 1928, Maue's History of Will County, collection of author

The Royal E. Barber home, Corner of Western and Hickory (Demolished)

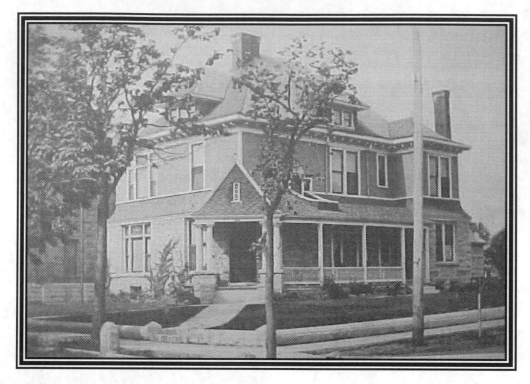

Why it's important: The Royal E. Barber home was the residence of one of Joliet's most prominent citizens in the 19th century. It also was one of the many fine large homes designed by architect F.S. Allen.

Style: The Barber home was an imposing Victorian blend of Romanesque massing with Colonial Revival features. The Romanesque is seen in the heavy stone used in the first floor. The Colonial features include the Palladian window on the staircase and in the attic on the opposite side.

The history: Royal Barber settled on the corner of Western and Hickory streets in the mid-19th century. City directories show R.E. Barber residing on Hickory as early as 1859. The home was a modest frame Italianate structure very similar to many of the homes in Joliet at the time. This house stood to the rear of the lot leaving a deep front yard.

Sometime around 1895 Mr. Barber commissioned F.S. Allen to design a new residence for him. Allen had already designed Mr. Barber's business block on Chicago St. (the Barber Building) in 1887, and had received school commissions through Mr. Barbers influence as a member of the School Board.

The new home was built on the front of the lot so the old house would be usable until the new house was completed. The space occupied by the old house was then taken up by a massive stone and frame carriage house that was attached to Marcus Krakar's next door.

The site of the Barber home today is an automotive service structure. The grand home was demolished fairly early on and replaced by a service station. One rumor is that Marcus Krakar tore down the house and built the gas station so he would not have to go far to fill up his car, though that story can not be verified. This service station has changed hands over the years, but still remains an automotive garage.

Details: The Barber home is truly one of the great losses in Joliet homes. The house design optimized the corner lot setting by facing the entry to the corner. This was a feature not commonly used. Typically one street or another was used as a focal point for the home.

One of the most striking features of the home is how the second story is set back from the main floor with a decorative cut shingle sweeping band. This design element was very common is some of the more impressive and massive Queen Anne homes in Joliet.

Another excellent feature is the Palladian window on the staircase just up and over from the front door. It is unique how there is a window well cut in through the mid-section band of décor on the house. A period view of the neighboring Krakar home reveals there was a large protruding curved room on the other side of the house.

The people: Royal E. Barber was born in Benson, Vt., in 1822. When he was 10 years old, he moved with his family west. He worked the land, though he was plagued by fever and chills recurring every harvest season. He came to Joliet in 1845 to seek out new work. By that time, he had established an 80 acre farm.

He worked in the office of the Deputy and City Clerk while he studied law and in 1847 was admitted to the bar and began to practice in this circuit. In 1852, after having served as deputy clerk for four years, he was elected Circuit Clerk.

Mr. Barber was elected mayor of Joliet in 1876, and for 9 years, he served on the School Board. He also was a trustee and Ruling Elder for Central Presbyterian Church. Mr. Barber is buried in Oakwood Cemetery.

Did you know? At the age of 16, R.E. Barber worked the farm during the summer and taught school during the winter months.

Illustrations:

R.E. Barber home, 1895 Artworks of Joliet, courtesy of the Joliet Historical Museum

R.E. Barber, ca. 1880, courtesy of City of Joliet

Original Barber home, 1873 Atlas of Will County, collection of author

Barber home site today, photo, author

The John J. Welch home, 263 N. Center St

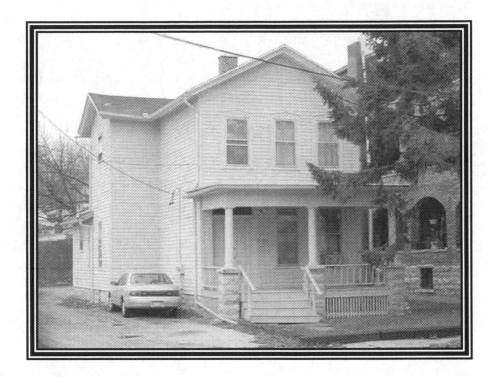

 Why it's important: The Welch home is a very good example of a middle class Victorian home from the 1870s. Mr. John J. Welch was also the first paid employee of the Joliet Fire Department.

 Style: This home is a modest 2 story Italianate structure. This style is best seen in the subtle curved top windows, original double doors. A small porch on the north side with its original post and decoration also exemplifies the Italianate style. There is also a Classical porch which stretches across the front that was added around the turn of the century.

 The history: The home at 263 N. Center was constructed around 1874 for the family of John Welch. The family owned a large plot of land in this block including the land reaching the corner of Western and Center. At the time of the construction of this home, most of the Western Avenue and Center Street area was sparsely populated with smaller homes mostly in the Greek Revival or Italianate styles. Many of these early homes have been replaced, or modified over the years.

The Welch family lived here through the end on the 19th and into the mid-20th centuries. They are also responsible for the construction of the large brick apartment building on the Southwest corner of Western and Center which bears the Welch name.

The home at 263 N Center St today is used as apartments. Mr. Welch's great great grandson Greg Vershay still lives in the Cathedral area.

Details: The home is an increasingly rare example of modest 1870s homes in close to original condition. Though many of the window hoods have been removed across the front, the sides still show the beautiful details from this period. Also still intact are the original front doors which so often have been replaced on these homes.

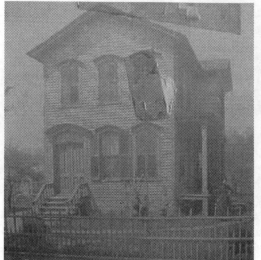

The people: John Welch moved to Joliet with his family from England in 1850. At the time John was only 7 years old. In 1868 John married Alice Adderly of Joliet. In 1869 he became the first paid employee of the Joliet Fire Department. He was hired to run the steam engine for the department. In later years John worked for the Bates Machine Company and the Elgin, Joliet & Eastern Railway.

Did you know? As the first employee of the Joliet Fire Department, John Welch was paid $50 a month for running the steam engine.

Illustrations:
263 N. Center today, photo, author
John J. Welch, ca. 1890, courtesy of Greg Vershay
263 N. Center, ca. 1875, courtesy of Greg Vershay

The Charles H. Conkling house, 1 South Center St.

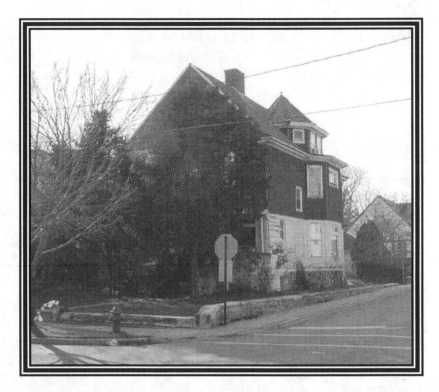

 Why it's important: The Conkling house is important for the original owner, and for its architectural style and architect.

 Style: The Conkling home is a classic example of the Queen Anne style mixed with some Colonial Revival elements. The Queen Anne is seen in the steep pitched roof, the offset semicircular bay on the second floor topped with a recessed window, and the tower on the north side. The Colonial Revival is seen in the large Palladian window on the south end of the second floor.

The history: The Conkling home on Center Street is the second residence built by Mr. Conkling in Joliet. The first is no longer standing. He constructed his home on this site in the early 1890s. The home is built in a stretch that became a unique small row of mansions along the west side of Center St. The other homes on the block date around the same decade including the Haley home 1891 and D'Arcy home built in 1899.

The Conkling home is attributed to Hugo Boehme who was known to have designed other homes in this style. A classic example of that is the Goldberg home on Comstock which is extremely similar in design and massing, though less inspired by the Colonial

Revival style.

The Conkling home has gone through many owners over the over 100 years it has stood on the corner of Washington and Center. For many years it was subdivided into a rooming house or apartments. The home was purchased by the Richard Olsen family in the late 1980s and has been preserved as a single family home since.

Details: The Conkling home is a wonderful example of late 19th architecture in Joliet. The front of the house is dominated by an elegant full front porch with a curved protrusion following the semicircular bay on the second floor. This is supported on a massive stone foundation.

The main body of the home is frame and although the second level is sided, the original clapboard still remains on the main level. The curved bay and side trapezoidal bay were originally topped with heavy balustrades 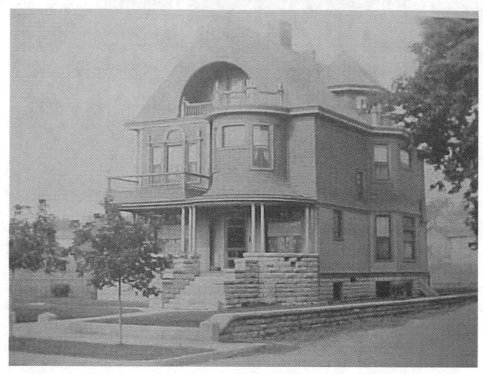 seen in the original photo. These added to the Colonial Revival design of the home. The interior of the home is still intact with massive oak staircase, original fireplace mantels, and French doors.

The people: Charles H. Conkling was born in Cambridge City, Wayne County, Indiana, November 1, 1853. The family moved to Chicago and established the Conkling Bros. & Co. After the Chicago fire, the family moved to Morris IL in 1873 and then to Joliet in 1876 and became proprietor of the Robertson house here.

Charles came with his family, and entered the Will county National Bank in 1880 as a teller. He remained there for three years when he took a position in Chicago for a commission business in the stockyards. When Colonel Shurts assumed control of the Duncan hotel (formerly the Robertson house) Mr. Conkling was appointed manager until he was offered a position with the Mutual Loan and Building Association. He also had many business interests including fire Insurance and the Union Steam Laundry.

Mr. Conkling was married in 1874 in Morris IL to Jennie A. Hynds daughter of a very prominent Judge and Lawyer in Morris Patrick Hynds. To the union were born 2 children Mary E. and Pink.

<u>Did you know?</u> The two daughters of Mr. and Mrs. Conkling were both graduates of Notre Dame, and were accomplished musicians.

Illustrations:
1 S. Center today, photo, author
Charles Conkling, 1887, Joliet News supplement, August 18th, collection of author
1 S. Center, 1897 Artworks of Joliet, courtesy of the Joliet Historical Museum

The Patrick C. Haley home, 17 South Center St.

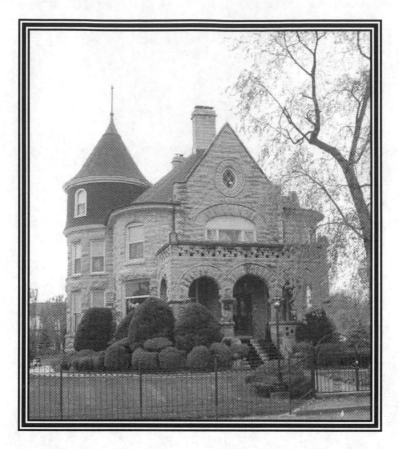

Why it's important: The P.C. Haley home is one of the finest limestone residences in Joliet. It was also the home of a mayor of Joliet from the late 19th century.

Style: The Haley home is a massive 2 and a half story Richardsonian Romanesque home. This is seen in the heavy rough cut limestone and massive arches across the front of the home. The house also reflects the Chateauesque style with its steeply pitched roof and graceful finial on the tower and slim long proportions. Another quite unique feature which is now lost under additions and alterations, is an open 2 story arcaded back porch.

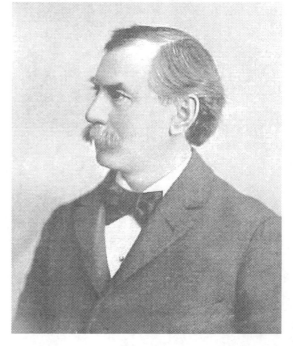

The history: The Patrick Haley mansion was constructed in 1891. This date is inscribed in the stones at top of either end of the front porch. The home was designed by local architect F.S. Allen who lived only a few blocks away.

The 8,600 square foot home took 2 years to complete. Afterwards it became one of the key social homes in the city. The residence was owned by Mr. Haley until his death. The home then passed to his three unmarried daughters who continued to live in the house. Through the years, it has been a

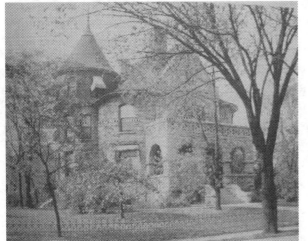

residence and Haley Funeral Home (no relation) for over 30 years.

The home is owned today by Jeffrey Bussan who has a catering business. The catering business had been growing in the Joliet area and in 1995 he decided to open his own mansion banquet facility. He loved the history and architecture of the Haley home and considers himself only a temporary keeper of this fine residence which he says will stand for a long long time to come.

Today the home is open and available for weddings and parties. A large banquet addition is being constructed on the north side of this structure at the time of this writing.

Details: After rising up the large stone stairs to the massive oak front door, the visitor to the mansion is greeted with a small entry vestibule and then enters a large reception foyer. The room is dominated by a large oak staircase on the right with a stained glass portrait of P.C. Haley set into the wall above the landing.

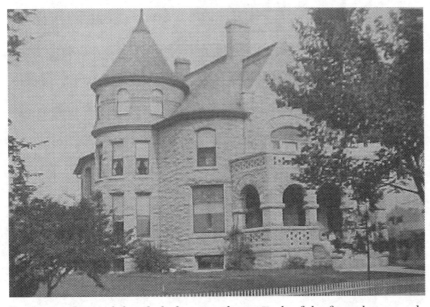

The hall has one of the 4 ornate fireplaces on the first floor. All are decorated with wood mantels and original tiles surrounds. The front parlor has a tall pier mirror across from the entry. The separation between the two main parlors is done with an intricate scrolled fret work piece.

All of the formal rooms have elaborate embossed borders and raised detailed plaster ceilings. Each of the formal rooms also hosts at least one leaded or stained glass window. The most impressive of these is in the rear south room and is a long highly detailed leaded window.

The upstairs of the house has been drastically altered to accommodate its new use, but much original woodwork and details still remain. The third floor of the house now waiting rooms for brides and grooms, originally was the school room for the Haley children.

The people: Patrick C. Haley was born in Sarinac, New York, in 1849, and in 1851 his parents moved to Joliet. He attended public school in Joliet and graduated from Joliet high school. He then attended the Law School of the University of Michigan. He graduated in 1870 and immediately entered into practice in Joliet. In 1874, his party elected him City Attorney which office he held for 2 years. He served for 14 years as alderman of the Fifth Ward. In 1891, he was elected Mayor of Joliet a position he held for 2 years.

In 1875, Patrick married Mary D'Arcy, of one of Joliet's pioneer families. They were the parents of 9 children.

During the last part of Mr. Haley's career, he was deeply involved in law cases dealing with the Right of Eminent Domain, and by his death he was considered to be the leading authority on the

Law of Eminent Domain in Electric Law. Mr. Haley died in 1928, just under 2 months after his wife's death.

Did you know? Because of Patrick Haley's Irish ancestry, F.S. Allen designed Celtic symbols to be carved at the base of each of the 4 supports for the porch. Each one is different.

Illustrations:
17 S. Center today, photo, author
P.C. Haley, 1900, Come to Joliet, courtesy of the Joliet Public Library
17 S. Center, 1916 Artworks of Joliet, courtesy of Andrea Magosky
17 S. Center, 1895 Artworks of Joliet, courtesy of the Joliet Historical Museum
P.C. Haley, 1897, Joliet Illustrated, courtesy of the Joliet Public Library
P.C. Haley, 1928, History of Will County, August Maue, collection of author

The Major Max Goldberg house, 230 Comstock St.

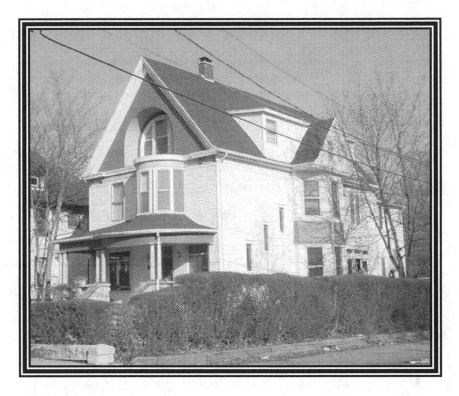

Why it's important: The Major Goldberg house is one of a handful surviving documented homes designed by local architect Hugo Boehme. Mr. Goldberg was also important as a Spanish American War Major, and local businessman.

Style: The Major Goldberg home is an imposing Queen Anne style residence. This style was prominent in the United States from the late 1870s through the early 20th century. The style is seen in the semi-circular bay window on the front and recessed attic window with elaborate cut shingles.

The history: The Goldberg house was designed in around 1895 by local architect Hugo Boehme. The family lived in the home for many years. When the home was built there was a large Carriage House to the rear of the main house, seen in the original photograph.

The house has gone through several owners over the years, and at some point in the mid-20th century, was converted into apartments. Although many original features still remain, much of the house was stripped during these years and large dormers were added to the roof. The original Carriage House was also lost during this time.

Wally Piper purchased the house in 1984 after many of the alterations and renovations had been made to the home.

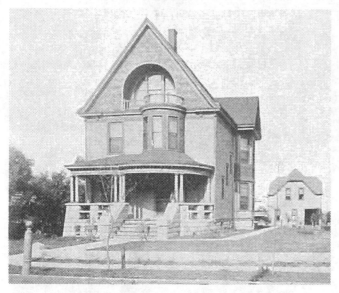

Details: Despite the many years of rental use and neglect, the Goldberg house still has many beautiful features. Staring with the outside, the fish scale and cut shingle details in the sweeping front gable and side gables are still intact, as is the large full length front porch which curves to follow the line of the bay window.

The interior has many original features. You enter the house through the original oak door into a small vestibule, and then into the entry hall. The hall has a large original Oak Staircase and Oak Fireplace. There are also stained glass windows on the staircase added by the current owner.

The main apartment has the one inlaid floor exposed, and a large open atrium was cut through to the second floor to give this unit its own internal stairs. The office which originally was the breakfast room is the only room in the apartment to have a majority of its original woodwork.

The people: Max Goldberg was born in Koenigsburg Germany in 1857. In 1878 he married Jennie Weinberg, and came to Joliet in 1888. He started in business in Joliet as a dealer in scrap iron and metals, with a shop on Bluff St. In 1894 he opened a Hard and Soft coal business with the branch office at 604 Cass. St.

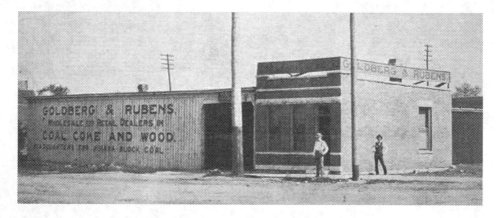

To the couple were born three children. Not much is known of two of them, but their daughter married a Chicago man by the name of Louis Rubens. They were engaged in 1898 and married soon after. During this time Mr. Goldberg served with the 3rd Ill in the Spanish American War and achieved the rank of Major.

<u>Did you know?</u> Major Max Goldberg's son in law Louis Rubens would go on to built the Rialto along with a great many others theaters in Joliet.

Illustrations:
230 Comstock today, photo, author
Major Max Goldberg, ca. 1905, Come to Joliet, courtesy of the Joliet Public Library
230 Comstock, ca 1897, Joliet Illustrated, courtesy of the Joliet Public Library
Goldberg and Ruben Coal, Coke and Wood, ca. 1905, Come to Joliet, courtesy of the Joliet Public Library

The William Moore house, 301 Nicholson St.

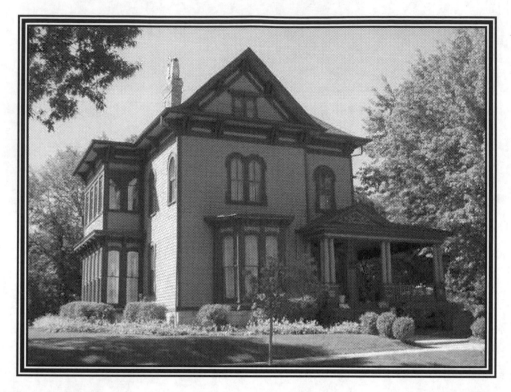

Why it's important: The Moore house was the home of William Moore, founder of Moore Solar Stove Works. It is also one of the earliest homes along Western Ave.

Style: The Moore house is an Italianate style home with Colonial overtones added. The Italianate is seen in the heavy corbels on the eaves and round topped windows with fancy window hoods. The Colonial Revival is seen in the Classical porch and steep roof line that was a later addition.

The history: The Moore house was constructed around 1872 when William Moore moved to Joliet. The house was the first home built in the Glenwood subdivision, which was laid out in the late 1860s. The only older house is the Campbell house, which was the original homestead for the area which is located across the street.

Moore lived in the house until his death. It was then held in the family for a short time, though it is known to have changed hands by the mid 1880s. Over the years many residents have come and gone. One put a major facelift on the home, adding the front porch, changing from the original double doors and adding a steep sweeping roof replacing the original flat roof. There are still elements of the original roofline present in the attic.

The Moore house was purchased by Derek and Sherrie Hackney a few years ago. They have undertaken a major restoration. Of the many things that have been done include the removal of the aluminum siding, roof replacement, and restoration of all of the elegant exterior details. The house is painted in a historical color scheme which reflects some of the original colors found on the house. On the interior the Hackneys have worked to collect period furnishings and lighting for the house.

One of their prized possessions is a fully restored Moore Parlor Stove which they use to supplement the heat in the house.

Details: The William Moore house commands an impressive view sitting at the top of Western Avenue. The house is oriented to look over the city from the front rooms. The entry is through a single door which replaced the original double doors. The entry hall is dominated by a large sweeping staircase. A door to the left leads into the formal rooms.

The main parlor has a fireplace and large bay window facing east. A grand archway separates the second parlor from the first. The second parlor leads to a small conservatory on the south side, and dining room on the north. The dining room was altered in the colonial remodeling with a wainscoting added and multi light French doors. The floors are all oak, and in the main parlors have inlaid boarders.

To the rear are another parlor and the kitchen. There is also a slim hall which has the servant's staircase. The upstairs has several bedrooms, the front one having a fireplace above the one in the front parlor. There is also an upper sunroom added when the house was remodeled.

The people: William Moore came with his brother Alexander to Neenah Wisconsin, and in 1857 started a foundry. Business was slow at first, but began to grow by the late 1850s. They also during this time began building stoves.

In 1871, William Moore, seeking a larger market, moved to Joliet and constructed a foundry and named it the Solar Stove Works. Alexander died in 1873 in Neehan WI and William died in 1875 in Joliet. The business continued as the Solar Stove Works until 1887 at which time the Joliet Stove Works was founded under the management of William N. Moore and Lewis Moore. The stove works were renamed in 1907 as Moore Brothers Company.

Did you know? When the Moore house was constructed Nicholson Street was Park Avenue and Western Avenue was Cross Street.

Illustrations:
301 Nicholson St. today, photo, author
Detail 301 Nicholson, photo, author

The Henry Webster Tomlinson house, 304 Nicholson

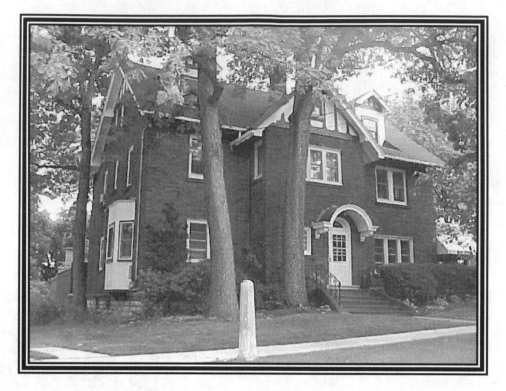

Why it's important: Aside from being a fine example of the Tudor style, Mr. Tomlinson was a well known architect across the country.

Style: The Tomlinson home is a large and impressive English Tudor house. The style is seen in the simple brick massing with half-timbered gables at the roof line. The house is more simple and restrained than most Tudor homes of this period, many of which have more rugged brick and stone walls, and much more surface area given over to the half-timber.

The history: The residence at 304 Nicholson was built around 1918 for Henry Webster Tomlinson from his own plans. The house is constructed just off the corner of Western and Nicholson, and was constructed in what at one time was the front yard of the William Strong house. That residence was reoriented to face Nicholson St. when this and the neighboring house on Western Ave. were constructed. The home appears to have housed two families from the time of construction. Tomlinson was the sole resident for only a couple of early years. He resided in the house until his death in 1942.

The home was purchased after Tomlinson's death by the Litchfield family who had a dress shop in downtown Joliet. The home was purchased in 1985 by Richard and Susan Semrov who reside in the home along with Richards's sister. They have continued to preserve the beauty and integrity of this Historic Home.

Details: The exterior of the Tomlinson home is set off the corner to allow for a large side corner yard. The home is approached by a simple yet elegant stairs which lead to the arch topped door

with small decorative hood. There is simplicity to the entry here that is quite common in the Tudor Revival Style.

The Tomlinson house appears to have been a single home later converted to a multi-unit. The home enters into a vestibule with a small Colonial style railing leading to the upper floors, and a simple door leading to the main level apartment. The front stairs contrast sharply with the heavy Arts and Crafts service staircase which winds up the rear of the house. This indicates the replacement of the front original stairs. Most of the time Henry lived there, there were various other residents and it is considered Henry himself who cut the house into apartments.

The interior has beautiful original crystal door knobs and pulls on an abundance of original built-ins. The home had a servant call from the kitchen to the servant's quarters on the third floor. There is also a service button on the floor in the Breakfast Room which could be discretely tapped with the foot while sitting at the table.

A stunning pair of beveled glass doors leading from the living room to the southern porch. These appear to be almost too contemporary to be original to the house, but reflect the modern design of the home. The home today is related living with the owners residing on the first floor, and his sister residing in the upper level which originally was the servant quarters.

The people: Henry Webster Tomlinson was a well know architect throughout the United States. He was born in 1870 in Chicago and grew up there and went on to study architecture. During his early years in practice, he had an office in Steinway Hall downtown Chicago, and was a friend with many prominent architects including Frank Lloyd Wright and other Prairie School architects. When Wright opened his Oak Park office, Tomlinson worked with many of Wrights Chicago designs. In fact it was Tomlinson who would connect Wright with another famous Prairie School architect Walter B. Griffin.

In 1918 Tomlinson moved to Joliet and worked on completing the construction of Statesville Prison designed by W. C. Zimmerman. After Zimmerman's death Tomlinson became the leading architect for the prison. Over the next decades, Tomlinson would become one of the most noted prison architects in the world. Aside form his prison work and his personal residence; he designed many fine residences in Chicago and Joliet, though most of these commissions are yet undocumented. One interesting documented design of Tomlinson's is the Pool House and Pavilion in Nowell Park.

Did you know? Henry Webster Tomlinson was the only partner Frank Lloyd Wright ever had, though it is commonly accepted this was a financial partnership only and Tomlinson never participated in any of Wrights artistic work, recently I have found a Prairie style home in Oak Park attributed to both Tomlinson and Wright.

Illustrations:
304 Nicholson today, photo, author

EAST SIDE

The Nelson D. Elwood house, corner of Scott and Cass St. (Demolished)

 Why it's important: The Elwood house was the home of the 3rd Mayor of Joliet, and father of a later Mayor James G. Elwood.

Style: The Elwood house was a classic mid-19th century Italianate style home with a front gable roof. The style can also be seen in the simple full front porch, and corbels on the eaves. The simple frame design was popular in Joliet from the late 1840s through the turn of the century.

The history: The Elwood home stood on a prominent corner in downtown Joliet, though it was not the busy business corner we know it as today, when the home was built.

The house was constructed in the late 1840s or early 1850s by Nelson D. Elwood for his family. It was constructed on one of the finest residential streets in Joliet at the time, Scott St. Many prominent families lived on Scott and Chicago streets in this era. Eastern Ave. had only 2 or three houses on it and was considered living at the city limits. Western Ave was Cross St. and had no home facing it.

The home stood longer than most in downtown, surviving into the 20th century. It is almost a miracle that it stood for so long. The Brooks house which stood next to it was demolished some years before the Elwood house came down in order to clear space for the new government building at Scott and Clinton.

The home was finally demolished to make way for a valet parking deck for the Louis Joliet Hotel. The simple multi story structure had small single person platforms that lifted through holes in the concrete floors to take them to the cars. The garages was used for several years before being faced in brick and having a large showroom added off of the front of the structure.

At that time the garage was turn into an auto showroom. It would serve this use for years, eventually being recycled into a bakery. This was the last use of the old Louis Joliet Valet Garage. The entire structure was demolished and the site currently houses the Social Security building.

Details: The Elwood home was on the smaller side by today's standards, but for the time it was constructed it was a considerable house. In pre Civil War America, many of the homes were of a much more modest size than the later Victorians. Joliet was still in its early founding days, and the fortunes of the Post Civil War had not been made. This house stood as a great reflection of that era.

The people: Nelson D. Elwood moved to Will County in 1837 and originally settled in Lockport before finally moving to Joliet. While living in Joliet he served in many public and private positions and was one of the leading men of early Joliet history.

In 1847 N.D. Elwood was admitted to the Bar on will County and the State. Among his public positions he served as County Clerk from 1843 until 1849. He served as Mayor in 1855 and 56, and Alderman from 1857 until his death in 1861.

On the Business end, he was a founding director and Secretary of the Chicago & Rock Island Railroad Company. He also established the Joliet and Indiana Railroad with Joel A. Matteson. He also built a very prominent legal business with Judge G.D.A. Parks which lasted through his life.

Did you know? Scott St is named for Phillip and Seth Scott pioneers of Joliet who came in 1831 and 1832 to settle.

Illustrations:
Elwood house, ca. 1910 postcard, collection of author
Nelson D. Elwood, Will County History, George Woodruff, collection of author
Ariel of Elwood home, 1916 Artworks of Joliet, courtesy of Andrea Magosky

The Benjamin Richardson and W.W. Stevens Home, 19 S. Eastern Ave.

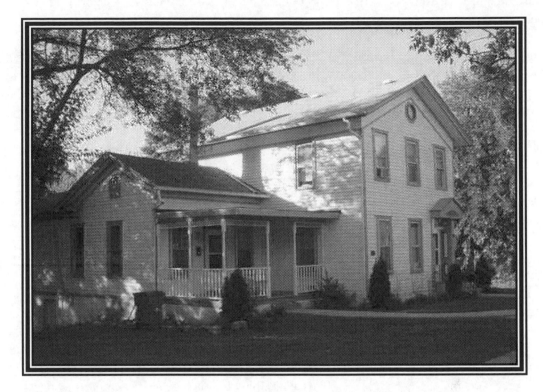

Why it's important: The Richardson / Stevens home is one of the earliest documented houses in Joliet. It is also home to two important early settlers of Joliet.

Style: The home at 19 S. Eastern Avenue is a mix of two styles reflecting the construction of each portion. The south side of the home is a simple one-and-a-half story vernacular home with Greek Revival overtones. This is seen in the short returns on the eaves. The larger two story portion is simple Italianate with a low pitched front gable roof. The entry has sidelights and a transom that also reflect the Greek Revival style.

The history: The Richardson home which is the south half of the house was constructed around 1842. It is a simple house and is the first known house on Eastern Avenue. Eastern Avenue was annexed to Joliet in 1838 by Joseph Campbell. Of the early property buyers only Richardson shows up as living in the area. His house is built on the eastern edge of what was in the 1830s a swamp created by the annual flooding of the river. Eastern Avenue was the high ground to the east of this swamp. This is probably why the house faces the direction it does.

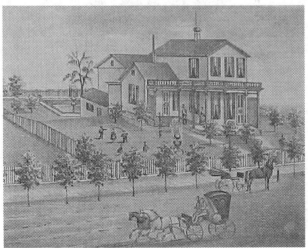

The large home was an annex built onto the house by Richardson's law partner, W.W. Stevens. Stevens joined Richardson in practice in the 1860s and built the adjoining larger portion of the home.

The home today is two units separated in about the same manner that it would have been in the 1860s. The house is owned by Ken and Carol Pritz who also own the Jacob Henry Mansion across the street. It is interesting to note that the other lots that Richardson owned on Eastern Avenue are the lots which the Jacob Henry home now stands.

Details: The Richardson / Stevens home is a unique example of early two-part construction. Some of the features which emphasize this are the two main doors. The recessed door of the original house has flanking windows and is in an earlier style while the larger portion is more typical of the 1860s in construction and design. The home originally had a full-length front porch which is seen in the 1873 view. This was removed some time in the mid 20th century, though it appears they used details from that porch when constructing then small top on the north entry.

The houses appear to be completely separate on the interior. They do not share a common basement, nor is there any access between the two portions. Although they have been divided into apartments, this appears to be a somewhat original layout.

The people: Benjamin Richardson came to Joliet in 1839 and is first listed as a chair maker. During his early years in Joliet he studied law and entered the legal profession, becoming the second Justice of the Peace in Joliet. In 1842 he purchased several lots in Campbell's addition to Joliet. One of the lots he built his home on. He lived on Eastern Avenue until 1869 when he collapsed in the pantry of his house after suffering from cancer and died. His wife and daughter lived with him at the time.

In about 1863, W.W. Stevens went into partnership with Richardson and their friendship went into the adjoining houses. After Richardson's death Stevenson would live in the house through into the 1880s. W.W. Stevens is best known for writing Will County Past and Present in 1900.

Did you know? With the way the Richardson / Stevens home is constructed, it could be considered the first duplex in Joliet.

Illustrations:
19 S. Eastern today, photo, author
19 S. Eastern, 1873 Atlas of Will County, collection of author
W.W. Stevens, ca 1900, Will county Past and Present, courtesy of the Joliet Public Library

The Jacob A. Henry home, 20 S. Eastern Ave

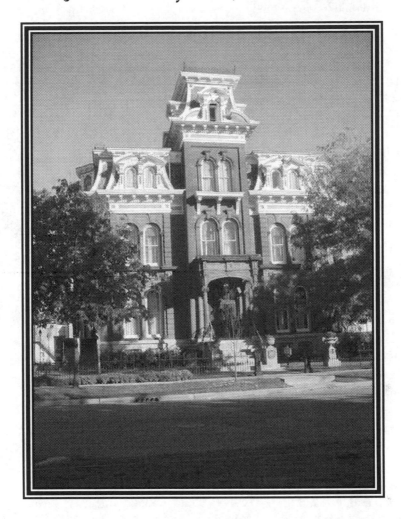

Why it's important: The Jacob Henry home is the largest and most ornate home constructed in Joliet. It was also the residence of one of Joliet's most prominent businessmen.

Style: The Jacob Henry home is an excellent example of the Second Empire style. The Second Empire design is seen in the classic Mansard or tall sloped roof with the flat top. The roof is adorned with heavy metalwork details and large broken pediment dormers which reflect the Italian Renaissance look. The style is further seen in the classical Corinthian cornice creating the eaves and Corinthian columns between the windows on the body of the house and supporting the porch. The house also has a Romanesque tower added later with a Byzantine copper dome.

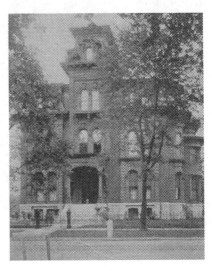

The history: Jacob Henry moved to Joliet in the 1850s. In 1865 he constructed the house to the south at 22 S. Eastern. As his business grew and his fortune built Mr. Henry

purchased the land to the north and started construction of this fine home. Ground was broken in 1873, and the home would be completed around 1878. The Egbert Phelps home which stood just to the north of the Jacob Henry home was purchased and demolished in order to provide adequate space for the home and yard.

During the construction a man by the name of Fritz Kettleholm lived with the Henry family and is listed as a laborer. It has often been said that Jacob Henry brought German craftsmen over to care the woodwork. At this time we believe Mr. Kettleholm was probably responsible for all the exquisite carving in the house.

The home was constructed with a large conservatory extending from the south side. This was removed by the second Mrs. Henry around the turn of the century and replaced by a two story Romanesque tower with a Byzantine dome.

Details: The Jacob Henry home is just full of fantastic details. Starting with the exterior the brick and brownstone construction is highly detailed with carved columns and topped with elaborate metal cornice's and iron railing. To the south there is a large tower which was added later. It has Romanesque style columns rather than the Corinthian on the rest of the house. This tower is also topped with a copper Byzantine copper Onion Dome.

The interior is a phenomenal treat for the eyes. Heavy carved woodwork dominates the first floor. All of this was carved specifically for the home. The long drawing room has cherub faces and lions heads carved into the wood trim. The office uses a darker wood and has a massive built in bookcase with a cylinder roll top desk. The library has one of the finest mantles with maidens carved in ebony, and squirrels playing with acorns.

The central hall has a massive staircase with a newel post larger than many guests of the home. From the hall there are pocket and swinging doors leading to all the formal rooms. Set to the rear of the first floor off the drawing room is the dining room. This has yet another theme to the woodwork. Here the style is more classical than romantic, and the wainscoting is carved with different panels of fruit and game.

The master bedroom suit is situated off the library and has the bedroom, along with dressing room and bathroom. The second floor of the home contains much simpler woodwork and several of the

104

rooms contain marble fireplaces. Mrs. Henry's room was located along the south side of the second floor. To the rear is the servant's staircase and stairs leading to the third floor which was never completed as living space.

The people: Jacob Henry was born April 25, 1825 in Hunterdon county New Jersey. Jacob

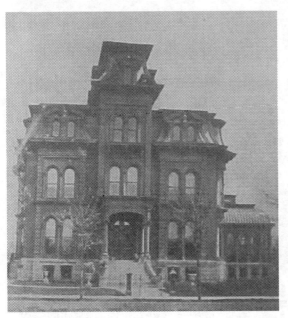

Henry married in Conn. in April of 1846. He and wife moved to Joliet in the 1850s. Henry had work with railroads since 1842. In 1858 he constructed 2 branch lines for the Chicago and Alton railroad.

Mrs. Henry died in 1878 and in 1885 he remarried. His second wife was Rachel Apgar. Henry had one daughter from his first marriage, Helen J., who married Dr. Julius W. Folk in 1867. She resided with her husband (and two children, Mrs. Frank Rich and Jay Albert) in her father's original home. Henry's second wife put her stamp on the house when she removed a 20-foot conservatory from the south side and added a two-story tower with copper Byzantine dome. After Mr. Henry died his second wife lost the home when she put it up as collateral to save the Will County National Bank from failing at the start of the Depression. But the bank failed anyway.

Among Mr. Henry's other business interests were, the Driving Park, Will County National Bank, the Opera House Block, Joliet Street Railway and Chicago Stone Company.

Today: Ownership changed through years. For many years it was the Harris Funeral Home, then a rooming house. Alan and Virginia Ferry bought it (when), started to restore it and got it placed on the National Register of Historic Place. The Henry home is owned by Ken and Carol Pritz, who have lovingly restored it and now use it for banquets, mystery dinners and special parties.

Did you know? Although Henry built the best house in town, he was not Joliet's richest citizen. He would have been rated somewhat low on the top 20 list.

Illustrations:
20 S. Eastern today, photo, author
20 S. Eastern in 1900, Come to Joliet, courtesy of the Joliet Public Library
Jacob Henry in the conservatory ca. 1890, courtesy of the Jacob Henry Mansion
20 S. Eastern ca. 1890, courtesy of the Jacob Henry Mansion

The J.A. Henry & Dr. Julius Folk home, 22 S. Eastern Ave.

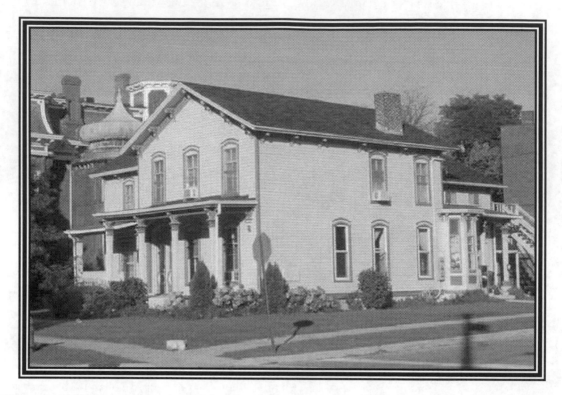

Why it's important: The Henry / Folk residence is a wonderful intact example of the common 1860s Italianate style. It is also the original home of Jacob Henry and home of the Folk family.

Style: The Julius Folk home is a Vernacular Italianate style home with an end and side gable creating an "L" shape. The style is seen in the elaborate cut brackets along the eaves and the curved top windows. These details again are seen along the original porches.

The history: Jacob Henry purchased lots 7 and 8 in Campbell's addition to Joliet in about 1863. It is on lot 7 and some of lot 8 that he built his first home on. The rest of lot 8 is First Avenue. The early home was a simple front gable house with a smaller service wing in back and full porch along the front.

In 1869, Mr. Henry spent $800 and added the north wing of the house. This added extra living space for his daughter her husband and their new child. In 1873, Mr. Henry began construction on his new house at 20 S. Eastern and the smaller house would then be known as the Folk house.

Mr. & Mrs. Folk would reside in the home well into the 20th century with little alteration to the home.

The Henry / Folk house today is used as a multi unit residence. Though rental property, the exterior of the home has been restored and is highly cared for. The house is owned by Ken and Carol Pritz who also own the Jacob Henry Mansion, Mr. Henry's second residence. They feel it

only fitting that the two houses should be kept together as they were for so many years in their early days.

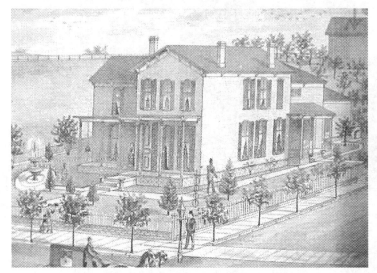

Details: The Julius Folk home is a wonderful Civil War era home. The wonderful details on the porches and eaves make this a key example for its style. One of the great features of the home is the small conservatory, or sun room which extends to the south of the house. This simple bay of large windows is the only such example of an early conservatory in Joliet. When Jacob Henry built his larger home, there was a very large conservatory on that house (since removed). The tall original double doors enter into the main portion of the house. Although now used as a multi-unit building, many of the original features remain, including marble fireplace and original woodwork.

With the exception of the remodeled windows on the first floor of the north wing, the Henry / Folk house looks much the same as it did when completed in 1869.

The people: Jacob Henry was a successful Railroad magnate in the mid-and-late 19th century. He came to Joliet in the 1850s and built his first home on Eastern Avenue in 1864. In 1867, his daughter Helen married Dr. Julius Folk and the young couple resided in this home. Dr. Folk was born in 1842 in Abbottstown Pa., and came to Joliet in 1845. In 1862, he enlisted in Company B of the 100th Ill Volunteer Infantry. He was immediately made a corporal and assigned to hospital duty.

He took active part in the battles of Laverne, Stone River and Chickamauga. He was discharged with a surgeon's certificate in 1864 and went on to Chicago Medical College and graduated in 1869. He practiced medicine for two years before entering into the railroad business with his father-in-law.

The Folks had two children Jay Albert and Ethel. Both continued to reside in Joliet. Many old time former Eastern Ave residents still remember Mrs. Folk living in the house.

Did you know? When constructed, Mrs. Henry actually owned the house. It was common in this area for wives of businessmen to own the homes. In case their business failed, the family home was safe from business ties.

Illustrations:

22 S. Eastern today, photo, author

22 S. Eastern, 1873 Atlas of Will County, collection of author

The Folk Family left to right Helen, Jay Albert, Ethel, & Dr. Julius, ca. 1900, courtesy of the Jacob Henry Mansion

The Benjamin Pickles house, 23 S. Eastern Ave.

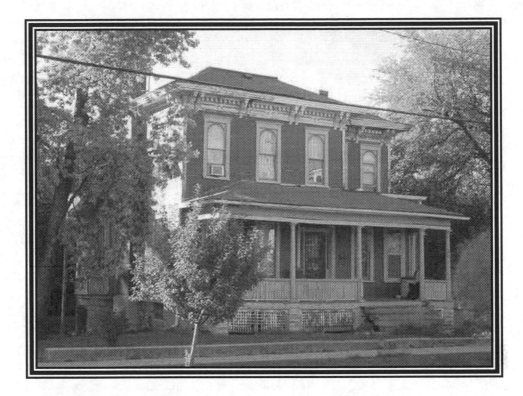

Why it's important: The Pickles home is one of the few grand pre-Civil War homes in Joliet. It is also involved in one the earliest murders in Joliet history.

Style: The Pickles home is a two-story Italianate style frame home. The style is seen in the flat topped hip roof with a cornice supported by paired brackets. The house also has round topped windows common in the Italianate style. A Classical porch and leaded glass entry windows were added around the turn of the century.

The history: The Pickles home is built on land purchased by Benjamin in 1855. The house stands on the northern edge of the four lots the Pickles family owned. In 1859, a bill was incurred for 18 loads of stone and enough wood to build a house. As the 1860 census places the Pickles family living at this location, it is assumed the house was constructed in 1859.

In 1873, city water was installed down Eastern Avenue, and in 1874, a kitchen wing was added to the rear of the house. Formerly, the kitchen was located in the basement. The house maintained this form until it suffered a fire around the turn of the last century. At that time, the double door entry was removed, and the present leaded glass entry was added. The porch was also changed as well as many interior features.

The house survived as a single family home into the 1980s when it was converted into a six unit rooming house. It stood vacant for two years before being purchased by Seth Magsoky. There were many changes to be reversed including the removal of several walls installed to separate the house into 6 units. Fortunately all of the woodwork was still in place and the house was overall very stable. The home was sold in 2004 to Michael and Cynthia Maloney.

Details: The Pickles home is an excellent example of a home of the growing middle class of the 19th century. Originally, the home featured all the comforts of the period. Mr. Pickles probate papers from 1861 show that the home was heated with stove heat as he owned a cook stove and two heating stoves. The formal rooms of the house were also carpeted as Mr. Pickles owned 60 yards of carpeting in 1861. Unlike many later Victorian homes, the 1850s style was to have painted woodwork, though an oak staircase was added to the home after the fire.

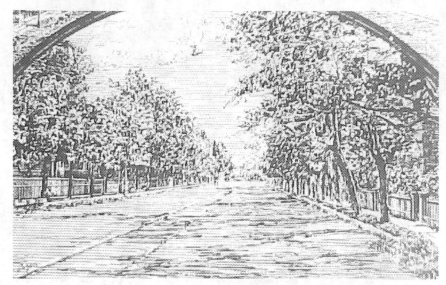

The lower level of the house had a full service area including original kitchen, servants room, and utility rooms. The kitchen on the first floor still has the original cabinets from the 1874 addition. Other features of the home include an 1870s marble sink in the first floor bathroom, a speaking tube from the master bedroom to the butlers pantry and servants' staircase.

The people: Benjamin Pickles came to Joliet in the 1840s as an aspiring businessman He first shows up as a carriage builder in the late 1840s and then as a blacksmith in the 1850s. He constructed his large home on Eastern Avenue in 1859 during the height of his career. It appears as he was not a simple blacksmith, but more of an artisan doing ornamental work on buildings.

In 1860, a lawsuit was filed by his brother-in-law for an unpaid bill amounting to about $1500.00. In that time that amount could build a house, and indeed it appears it built this as the bill was for stone and wood. The case was fought back and forth over the end of 1860 and early 1861. Not getting any satisfaction in the courts, William Zaph went to the Pickles blacksmith shop at the corner of Ottawa and Washington Streets, and at 8 pm December 6th, 1861, shot Mr. Pickles through the head.

The body was brought back to the house, and the hunt for Zaph was on. He was captured and a great amount of evidence was brought against him at his trial. He was convicted and appealed. In fact he appealed three times. As he waited for the final appeal, Zaph broke out of the old Will County Jail and was never recaptured.

The Pickles family lived in the home until 1884. The house then passed to the D.W. Castle family through the end of the 19th century. J.C. O'Conner owned the house around the time of the fire. The house was purchased in the early 1940s by Dr. Abram Sellards who lived in the house with his daughters and had his doctor office in the original dining room.

Did you know? In 1859, the year the house was constructed, Eastern Ave. became the first residential street to be plumbed for gas lighting. So this house is one of the first homes in Joliet to be built with gas lighting.

Illustrations:

23 S. Eastern today, photo, author

Eastern Ave street view, 1887, Joliet News supplement, August 18th, collection of author

The William Andrews home, 25 S. Eastern Ave

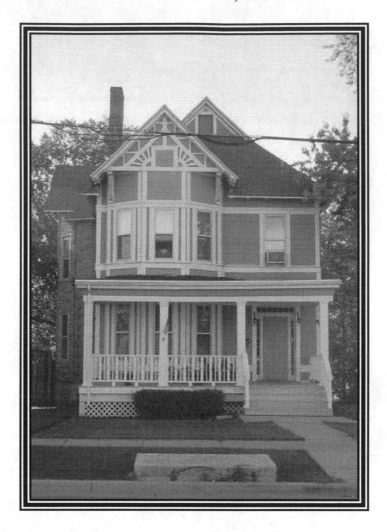

Why it's important: The Andrews home is an exemplary design by local architect Julian Barnes. It was also home to businessman W.A. Andrews.

Style: The Andrews house is one of the best designed examples of the stick style in Joliet. This style is seen in the way that the facades are split into decorative sections of framework that look like sticks. The panels are then filled with siding going in differing directions. The front gable is especially decorated on this home.

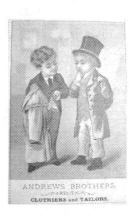

The history: The Andrews home was built on a lot originally owned by the Pickles family who lived just to the north. The lot was purchased in the early 1880s, and in 1884 there was an announcement in the Inland Architect and Building News noting that Julian Barnes was designing a home for W.A. Andrews. The completed cost was to be $3,500.

The Andrews family moved into the home and would maintain residence through the rest of the 19th century and the first half of the 20th century. During that time the home would be remodeled with a wrap around porch replacing the two original smaller porches. This porch would eventually be reduced in size. At this time it is also believed the double doors were replaced.

By the mid 20th century the Andrews home was divided into 2 units with Mrs. Andrews living on the main floor. The home would survive as a two unit until Barb Newberg reunified the home in the early 1990s. The house would change hands a couple more times until the current owners David and Juliana Pelc purchased it.

Details: The Andrews home is a classic example to design in the mid 1880s. Once you enter the home there is a large staircase rising to the second floor. Originally natural wood, it has long been painted. The staircase is accentuated by a stained glass window on the landing.

The house has the traditional front parlor, though many original features including the fireplace and pocket doors have been removed. The library still maintains the original built in bookcase. There is a rear staircase which leads to the servant's room.

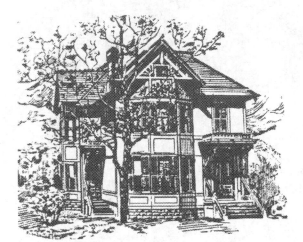

The three bedrooms on the second floor are all trimmed with original woodwork. The original pocket doors for the dressing area off the master bedroom still survive.

The people: William Andrews was a successful dry-goods merchant with a store in downtown Joliet when he built his home on Eastern Ave. Period newspapers are full of advertising for his store. After some time, Mr. Andrews left the dry-goods business and entered the School of Dentistry at Northwestern. He received his degree there and settled into a prosperous business in Joliet. The Andrews' had one son who resided in the home for many years.

Mr. Andrews died in the 1920s and was waked from the home on Eastern and buried in Elmhurst Cemetery. Mrs. Andrews would live in the home until her death in 1956 making her one of the longest surviving residents of the old guard on Eastern Ave.

Did you know? When Mrs. Andrews moved into the house Chester A. Arthur was president, when she died Eisenhower was president. She lived in the house through 4 wars, the invention of the automobile and the introduction of television.

Illustrations:
25 S. Eastern today, photo, author
Andrews Brothers advertising card, ca.1885, collection of author
25 S. Eastern, 1887, Joliet News supplement, August 18th, collection of author

The Albert W. Fiero home, 207 S. Eastern Ave.

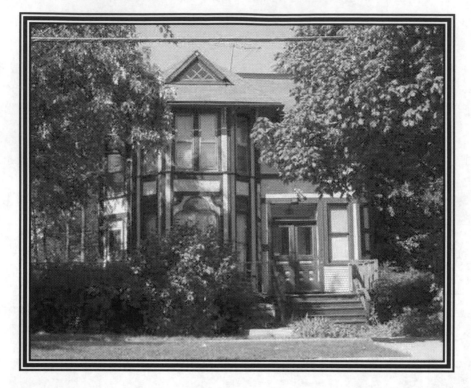

Why it's important: The A.W. Fiero home is an excellent example of the Queen Anne Stick Style. The home also house one of the prominent families of Eastern Avenue.

Style: The Fiero home is a two-story Queen Anne Stick style structure. The Queen Anne is seen in the asymmetrical massing and heavy protruding bay windows. The stick style is seen in the use of trim board placed to look as though they are separating the siding into section, or looking like stick placed on the house. This is best seen on the north side of the house.

The history: Albert Fiero purchased the Samuel Thompson home on South Eastern Avenue in 1885 and demolished the simple early home to build his larger residence. The home built in the Stick Style originally had three main bedrooms, or chambers, with smaller servants' rooms to the rear.

The house was expanded around the turn of the century with the addition of a new kitchen and several more bedrooms being added. It was at this time the entry hall was opened to an impressive 20 feet long, and a massive Neo-Classical wrap around porch was added.

The house was sold from the Fiero family in the early 20th century. The home passed through several families before finally being cut into several small units as a rooming house. In the early 1980s, Gerard DeRocher purchased the home and started the transformation back to a single family home.

The Fiero home was purchased in 2003 by Paul and Esther Grachan. They plan on continuing the restoration of their home, and have started the long process of researching the period appropriate style in which to decorate their home.

Details: The Albert Fiero home is entered through massive original double doors. There is a small vestibule and then a second larger pair of doors leads into the entry hall. This room is dominated by a mahogany and oak staircase which sweeps out into the room with paired newel posts. One of the curves slightly and has an original newel post gas lamp.

The is a very large pocket door which leads into the front parlor and two sets of pockets doors which connect the parlors together. All the pocket doors were recovered from the floor of the carriage house (now demolished). The center parlor has a fireplace with original mantle. The dining room, which was the original kitchen differs in design from the main rooms and reflects the Classical taste in woodwork. The house ends with the kitchen and a back staircase. The upper level has six bedrooms including the master two room suite.

The people: Albert Fiero descends from the Mayflower on both sides. He was born in Battlecreek, Michigan, and came to Joliet in the 1870s. He married Florence Carpenter, daughter of a prominent local preacher. To the couple were born two children Conro and Emilie. Mr. Fiero was a structural and civil engineer in Joliet. When his small company was purchased by a large Chicago firm in the early 20th century, the family moved to Grand Avenue in Chicago. There they would spend several years until Mr. Fiero started failing in health. He died in the Battlecreek Sanitarium.

After his father's death Conro proceeded to squander the family fortune. Leaving his mother poor, she again returned to Joliet and rented a room in the old Cochrane home across the street from her former home and lived out her days across from 207 Eastern. Emilie moved to New York and became an artist. Conro, after suffering ruin of fortune, ended up divorced from his wife.

Did you know? It was not uncommon in the last quarter of the 19th century to demolish smaller homes on Eastern Ave to build grander homes. This was done by Jacob Henry, Dr. Werner and Albert Fiero, to name only a few.

Illustrations:
207 S. Eastern today, photo, author

The Robert J. Morrison home, 400 Grover St

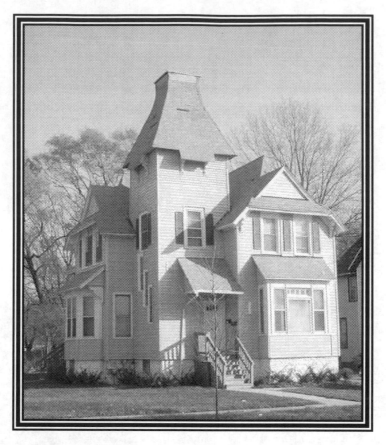

Why it's important: Mr. Morrison was a long time County and City Assessor, as well as Civil War Veteran. The home is also a unique example of the Queen Anne style.

Style: The Morrison home is a classic example of the Queen Anne style. This is seen in the steeply pitched roof and asymmetrical massing of the home. The tower though, is treated in a more unique flavor. It is a large square tower with a steep almost mansard style roof. The home has small porches which were common in the mid 1880s when the home was built.

The history: The home was constructed around 1884 by Mr. Wilcox for his family. The home was occupied for only a short time by the Wilcox family. After being damaged by a tornado the home was sold to the Morrison family.

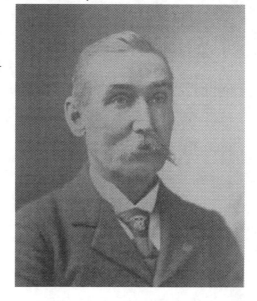

Robert Morrison purchased the home at what was the 200 Grover and would maintain residence there through the rest of his life. It was while living here he changed careers three times and raised his family in the home. The Morrison's would live in the home into the first quarter of the 20th century.

The Morrison home is today a multi unit residence. The home has been sided over with a loss of some details including the railing around the top of the tower, however many features and window placements are still intact.

Details: The Morrison home has always been noted for its large square tower which makes the building seem quite slim as it rises from its corner lot. Inside the tower is the original large staircase which originally rose to a sitting room in the top of the tower. This has unfortunately been closed off in recent years and windows covered over.

The interior of the home is arranged in a unique "Y" layout which allows access to all of the formal rooms from the dining room located on the north side. The second floor clearly denotes the main home from the service area where the floor is one step lower.

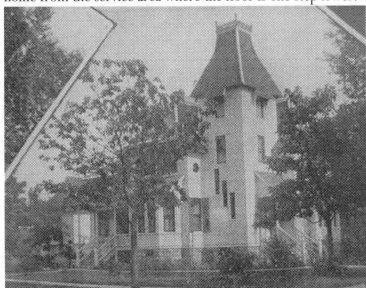

Much of the original trim is still intact throughout the house including pocket and swinging parlor doors. Also the trim around the large protruding windows is still present.

The people: Robert J. Morrison was born on May 1st, 1804, in New York City. He was the second of two brothers, and received his education primarily in Canada. On April 15th 1861, he enlisted in Company F, Second Tennessee Infantry, and was mustered in as a private. After the battles of Wild Cat, Mills Springs, and Cumberland Gap, he returned through Rebel lines to Tennessee in order to recruit for the Union.

There are a great many stories recorded about Mr. Morrison's forays during the war. He helped to establish several companies during the war years, and finally retired a Captain in 1865. He married in 1862 Miss Hester Snider. The marriage took place in Elizabethtown Tennessee.

In 1865 the couple settled in Troy Township IL. It was shortly there after that Mr. Morrison came to Joliet and was established as a pump man on the Fire Department. From there he built up a real estate business. In 1894 he was elected Township and County Assessor. This is a title he would hold in the early years of the 20th century. After then he would devote his later years solely to his Real Estate business.

To the Morrison's were born five children Lizzie, Mary, Minnie, William, and John.

Did you know? The father of Robert Morrison had a stop on his family farm in Tennessee for the underground railroad, and was arrested at lest 6 times during the war by the Confederate government.

Illustrations:
400 Grover today, photo, author
R.J. Morrison 1907, Will County Past and Present, courtesy of Joliet Public Library
400 Grover 1900, Come to Joliet, courtesy of Joliet Public Library
R.J. Morrison 1900, Come to Joliet, courtesy of Joliet Public Library

Kenyon residences, 205 Sherman St

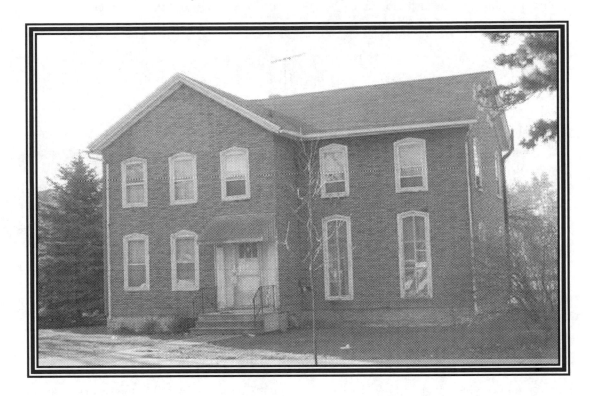

Why it's important: These two addresses are the know residences of one of Gerlach Barklow's most prominent artist Zula Kenyon.

Style: The home at 205 Sherman St is a simple vernacular Italianate style home. The home has been sided with a loss of detail more recently, but the style can still be seen in the very tall curved top windows.

The history: 205 Sherman St was constructed in the last quarter of the 19th century by the Rosenheim family. Mr. Rosenheim was a prominent merchant in downtown Joliet. It was constructed in the popular style of the day on an ample lot. The house passed from the Rosenheim family in the early years of the 20th century and then was sold again around 1910 to Mrs. H.K. Vreeland who used the home as a boarding house with various residents listed through the following years. It was at this time that Zula Keyon resided here.

The Rosenheim house still survives as a multi family residence.

Details: As a working female in the early years of the

20th century, Zula Kenyon lived in close range to the factory. She would have an easy walk to work from either residence. She also taught at the Art Institute of Chicago and these residences were in close proximity to the train stations.

When researching a female in the late 19th century and early 20th century, it becomes difficult as many single women were not listed individually in local directories, especially since she only ever rented while living in Joliet.

The people: Zula Kenyon was born June 15th, 1873 in Deanville WI to John and Anna Clark Kenyon. She also had a sister Haidee who is also a listed artist. In 1890 Zula was living with another family in Muscoda WI, and by 1900 she shows up with her sister and mother in Chicago.

By 1907 Zula shows up working for Gerlach Barklow as an artist for Art Calendars. She worked in pastels, and ground her own colors to create her special palette of colors. During her early years at Gerlach Barklow, Zula only signed her work by her last name since the executives at the company feared men would not buy calendars with art work by a woman.

Over the following years Zula became the lead artist for the company while also teaching at the Art Institute of Chicago. Her art work is commonly considered to be ahead of its time in style. At this time her sister was also teaching in Chicago.

Due to arthritis in her fingers, Zula was encouraged to move to a warmer dryer climate. It was at this time around 1918 that she moved to Tucson AZ, with her sister. By 1920 the sisters show up living in San Diego where they would spend the rest of their years. While they lived there they won prizes for their flower gardens off Nutmeg St. in Balboa Park in San Diego.

Though Zula moved to Arizona and then California, she still did artwork for Gerlach Barklow. Her last known copyrighted work for the company was in 1932. She died in San Diego in 1947. There are approximately 250 known works by Kenyon with about only 25 to 30 originals know to have survived. Among those surviving works is a portrait of John Lambert hanging in the stairwell of the Joliet Public Library.

Did you know? While working at the Art Institute, Zula Kenyon taught Adelaide Hiebel. It was Zula who personally recommended Adelaide as her replacement in the late teens.

Illustrations:
205 Sherman today, photo, author
Kula Kenyon 1890s, courtesy of Tim Smith

The Edgar E. Howard home, 207 Herkimer St.

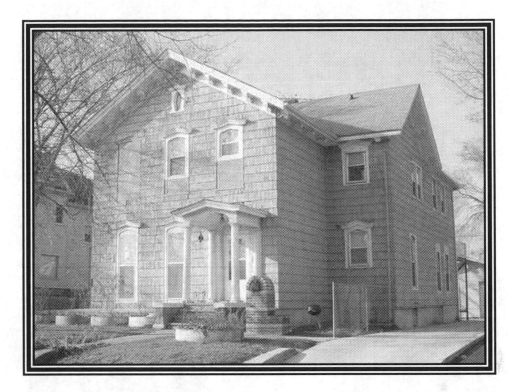

 Why it's important: The Howard home is important as a classic example of 1870s residential design in Joliet, and also as the home of prominent businessman Edgar Howard.

 Style: The Howard home is a typical Italianate style home. This style is seen in the corbels along the roof line, and bay window on the south side. Also noticeable are the heavy window hoods and slightly arch windows. In the 19th century a home with these windows was referred to as Gothic in design.

 The history: The Howard home appears to have been constructed some time around 1876. This was the year that Edgar Howard first came to Joliet, and the style fits perfectly with that time. In the 1870s Herkimer was growing as a fashionable residential street in Joliet. Other residents of the street included Henry Fish, Col. John Lambert, William Henry and Richard Doolittle, all famous names in Joliet history.

The home has gone through many owners over the years. Some time around the turn of the century the Howard home was sided with wood shingles over the original clapboard siding. This was a common remodeling done at this time and was the early 20th century equivalent to vinyl siding.

The E.E. Howard home is owned today by Ernesto Diaz. He was a renter in the home for several years, and when he had the money to invest in real estate he purchased the home. Today it is a multi unit home which Mr. Diaz hopes to maintain in the original historic appearance.

 Details: The Howard home is an excellent example of the simple Italianate style so popular through the second half of the 19th century. The heavy window hoods are highly detailed and bow

121

up to reflect the slightly arched windows. This window design is similar to other structures designed by local architect Orin Johnson, so this could possibly be one of his designs.

Around the door is wonderful heavy rope design wood molding. This ornamental treatment was also popular in the 1860s and 70s. Also of note is the bay window on the south side, with all its original detailing. The interior of the home still maintains much of the original elements, though some things have been removed over the years during various repairs and alterations.

The people: Edgar E. Howard was born in Milford Mass, September 15th 1845. He was one of 5 children. When his father became ill Edgar was only 13. He was obliged to begin working in the family shoe and boot factory to keep the business going until it was closed out at his father's death.

In 1864 he volunteered with the Fourth Massachusetts Heavy Artillery. He was to serve with this unit until July of 1865 when he mustered out. While in military service his unit guarded Washington D.C., and kept very special guard after the Assignation of Lincoln in April of 1865. At that time he took a position in a straw hat factory. In 1867 he moved to Sing Sing, N.Y. as an instructor in the shoe department of the state penitentiary. This was a similar position to that which would bring him to Joliet.

In 1876 Mr. Howard came to Joliet to work in the factory of Selz, Schwab & Co., shoe manufacturers at the state penitentiary. He would work here until 1883 when he would enter the insurance world. He started in the office of W.C. Wood and eventually took over the firm of Wood & Howard in 1890. He represented the most major firms of the day with the largest insurance providers.

He was married in New York to Miss Sarah Bowen on October 31, 1866. They had one child who was tragically killed at age 8 in a railroad crossing accident.

Did you know? It was reported around the turn of the century, that when Wood and Howard was in full strength they did not insure any company with assets of less than 1 million dollars.

Illustrations:
207 Herkimer today, photo, author
E.E. Howard 1900, Genealogical and Biographical Record of Will County, courtesy of Joliet Public Library

The Louis M. Rubens home, 112 Richards St.

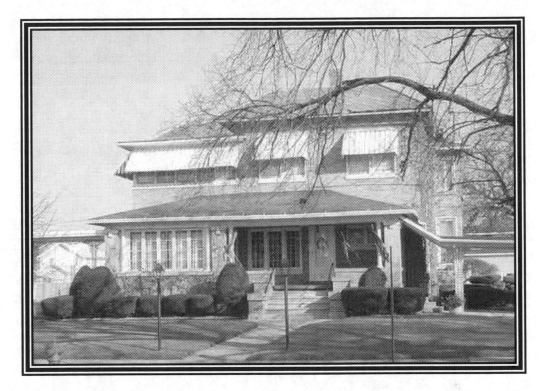

Why it's important: The home was the residence of Louis Rubens builder of many fine theaters in Joliet including the Rialto.

Style: The Rubens home is a Italianate home modified into the Prairie style in the first part of the 20th century. The Italianate is still seen in the massing and the lower hip roof. The Prairie and Arts & Crafts design is seen in the rows of multi pane windows, and massive brick porch with geometric details.

The history: The Rubens home was originally built for the Munroe family some time in the late 1870s or early 1880s. There is a notice in the mid 1880s by local architect Orrin Johnson about a remodeling to the house, though it does not state what that remodeling was, only that he did it.

The home was purchased around 1912 by Louis Rubens and his wife Becky. The couple would do much remodeling to the home bringing it to the current look. The home would be resided in by the family through the 1940s. By the 1950s the home was converted into the Blood and Grant Funeral home, and remained a funeral home since.

The Monroe/Rubens home is currently owned by Minor Morris Funeral home. The home is resided in by Mr. Morris and his family. The stunning details of the home have been maintained by the current owners.

Details: The Rubens home today stands as one of the finest interiors in the city of Joliet. Once you enter from the large porch you are immediately inside a wonderful spacious hall with a tall pier mirror. To the right the staircase is nestled into an alcove. Ahead the main parlor has tall ceiling with hand painted designs. At the end of the room is a fireplace with tile representing Romeo and Juliet. To the left of the entry is the Chinese room which has an oriental arch and used to have plaster dragons in the wall (recently lost).

To the south of the main room is another parlor. This room is the only one that retains the original décor. Huge paneled doors enter into this room which has plaster ceiling molding and an earlier marble fireplace. The walls are painted with floral swags and urns. The ceiling also has some decorative floral painting.

To the rear of the main parlor, large French doors lead to the dining room. This room is decorated with an inland tile floor with multicolor tiles in patterns. The room has a beamed ceiling and is also decorated with hand painted details. These paintings carry over to the small breakfast room off the east side. To the south of the dining room is the kitchen which has original tiles floor and walls.

The second floor of the home maintains many more original features than the first. It is reached by both a front and rear staircase. Like most houses of the period the home had servant's quarters in the home.

The people: Louis M. Rubens has been one of the most important people in the theatrical and movie business in Joliet. When Rubens was first engaged in 1898 and then married he worked in the Goldberg and Rubens Coal business with his father in law Major Max Goldberg.

In 1906 the two purchased the Bijou Theater on Chicago and Van Buren (later the Crystal stairs). This was their first but not last theater. By 1913 Louis along with his brothers established the Princess Theater on Chicago St. This constructions project was the stimulus for the establishment of the Royal Theater Company with Louis Rubens as its head. It was this company that constructed

the Rialto Theater in 1926. This was the pinnacle of the Rubens family success in Joliet. They owned several theaters and were part of the Great States networks which was established in 1925.

Did you know? The beautiful interior decoration added to the home by the Rubens family was created by the same artisans who created the fanciful interiors of their theaters.

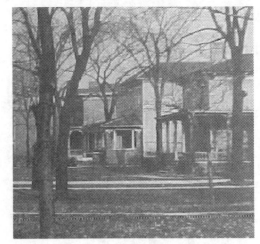

Illustrations:
112 Richards today, photo, author
Louis Rubens, Past and Present of Will County, courtesy of Joliet Public Library
Rubens betrothal card, 1898, collection of author
112 Richards, 1916 Artworks of Joliet, courtesy of Andrea Magosky

The Cornelia Miller/ Charles M. Fish home, Lincoln and Richards (Demolished)

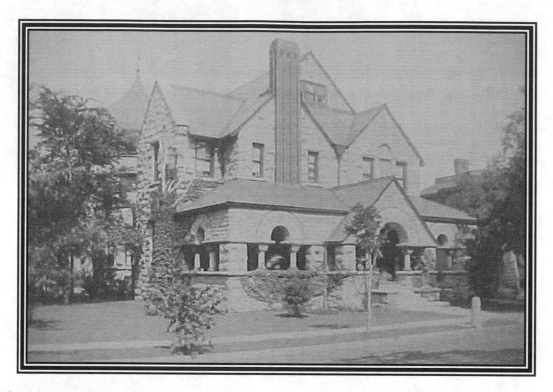

Why it's important: Joliet has had many great homes which reflect our history, but are now gone. Occasionally I will be featuring some of these lost treasures. The Miller/Fish home was just about the most unique and grandest homes ever built in Joliet. The family is also rich in history.

Style: The Miller/Fish home is an outstanding example of the Moorish style of architecture blended with the Romanesque style. The Moorish style is seen in the elaborate Byzantine or Onion dome above the tower and the sculpted floral detail seen in the Arabesque panel in the arch on the right side of the second floor. The Richardsonian Romanesque is seen in the heavy stone arches on the front porch.

The history: Constructed around 1890 for Cornelia Miller, widow of Edmund Miller, the home is best know for its second occupant Cornelia's nephew Charles M. Fish. The house stood at the corner of Lincoln and Richards and dominated 2 whole city lots.

Designed by local architect F.S. Allen, the house was built in the Moorish style with heavy Romanesque overtones. The house was expanded sometime between 1895 and 1916 with the addition of a 1 story conservatory or greenhouse added on the south side of the house. This room carries further the Moorish design of the home.

The home stood as one of the finest and most unique in the city before being demolished by Fish family to construct a large "U" shaped apartment building called "The Fish Apartments". The

apartments which replaced the Fish home in the 1930s were demolished in the 1980s and the site is currently being redeveloped by the city of Joliet with 2 nondescript low-moderate income houses.

Details: Aside from the stunning front details of the house, the home also had a large impressive carriage house. At 2 stories tall, the carriage house was constructed in the same materials as the house. The front was dominated by a large stone entry, and a tower was covered in fancy cut shingles.

The people: Charles Manning Fish was born August 1st 1859 in Joliet. His father Henry Fish had come to Joliet in 1834 and worked for his brother in law Joel Matteson. In 1854 he married Mary Manning and had 4 children, Charles being the third.

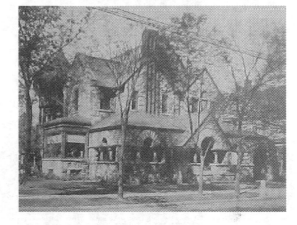

Both of Charles' parents can trace their family history back to Colonial America and both sides had family in the Revolutionary War. Also the family history traces directly back to the Mayflower, and Charles Fish belonged to organizations related to both.

Little is written of Cornelia, but we do know that Charles received his degree as a Civil Engineer, and engaged in the manufacturing business as well as the real estate business. Mr. Fish married Frances Louise Steel in 1887. The first Mrs. Fish died in 1892 and he remarried in 1898 to Miss Helen Thompson.

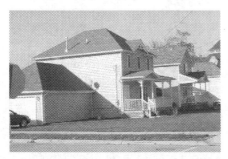

Did you know? The father of Charles Fish served as a delegate to the Presidential Convention that nominated Abraham Lincoln.

Illustrations:
Miller/Fish home, 1895 Artworks of Joliet, courtesy of the Joliet Historical Museum
Carriage house, 1916 Artworks of Joliet, courtesy of Andrea Magosky
Miller/Fish home, 1916 Artworks of Joliet, courtesy of Andrea Magosky
Corner of Lincoln and Richards today, photo, author

The Captain Charles Hill home, 401 Richards St.

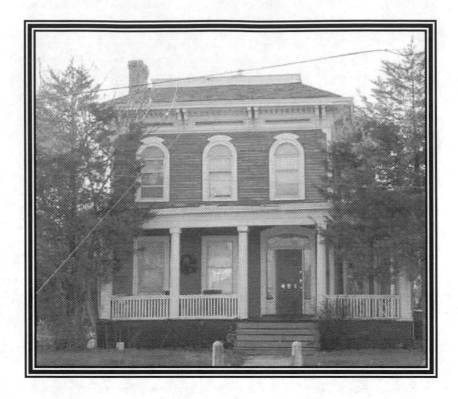

 Why it's important: The Hill home is associated with several prominent figures in Joliet as well as being an excellent example of the Italianate style.

 Style: The Captain Charles Hill home is a wonderful example of Italianate design. This is seen in the low hip roof with a flat top. Also typical of the style are the round and arched window hoods with beautiful detail. A small bay on the north side adds to the Italianate details, as well as the heavy corbels along the roof line.

 The history: The construction of the home at 401 Richards St is somewhat in question still. There is a home listed on the corner of Fourth and Richards in 1859 belonging to another person, though it is unclear if that was on another corner or in fact this house. We do know that by 1872 Charles Hill Civil War Captain was residing in the home.

In the 1872 County Directory it lists the house at the South East corner of the Joliet city limits. The Hill family would remain in the home well into the 20th century with the home passing into the hands of Frederick Hill who is probably responsible for the addition of the large porch and lavish leaded glass windows (now lost).

The home fell into hard times and was sided and in general disrepair going into the 1980s. A family then purchased the home and removed the siding and started to restore it. The house was brought back to its former glory on the exterior and was awarded building of the year for its restoration by the Joliet Historical Society in the early 1980s.

The Captain Charles Hill home was recently vacant and vandalized losing the beautiful leaded glass windows. The home was purchased and is used as rental. The owner is greatly interested in the history and preserving the house.

Details: The Charles Hill home is a wonderful Italianate home with lots of great features. The main house has beautiful rounded windows which are especially nice on the small north bay. There is also a bank of arc topped windows along the south side. The house has a classical porch which replaces the original small porch, but the rear porch is original.

The entry was alter at the same time as the porch and a single door with transom and sidelights replaced the original double doors. There were leaded glass windows there as well as on the staircase which are now lost. The house is topped by a cap ridge which would have supported a railing around the top of the house.

The interior follows the typical Italianate plan with an entry with a rather simple staircase rising straight up with the formal parlor with fireplace off to the side. Much of the original woodwork and plaster molding remains in the house.

The people: Captain Charles Hill was born in Truxton, Cortland County, New York on August 23, 1833. He was educated in Schools in Erie county New York. He came to Will County in 1854 and taught school for several years. He attended the commercial college of Chicago and read law with Judge and former mayor J.E. Streator in Joliet. He also read law in Indianapolis where he was admitted to the bar.

In 1860 he returned to Joliet and began practicing. On November 4th he married Lydia Wood. In 1862 he enlisted as a private in the 8th Illinois Cavalry. He was engaged in fighting at Gettysburg and Antietam while with this unit. In September of 1863 he was promoted to First Lieutenant C. A 1st Regiment Infantry United States Colored Troops. He would receive shrapnel wounds to the arm, as well as gunshot wounds to the side and chest in 1864. He ended the war with rank of Captain. He returned to Joliet and resumed law practice in 1865.

Among the several public positions he held were House of Representatives 1889-91, Assistant Attorney General of Illinois 1897-1900, and county prosecuting attorney. He lived in the home at 401 Richards until his death in 1902. His daughter would remain in the house with her husband until the death of Mrs. Hill. After that time Frederick Hill who had earlier built a home behind the original house on Fourth Ave moved into the home and remodeled it.

Did you know? The daughter of Charles Hill who remained in the house was married to an eager young traveling salesman named Theodore Gerlach, eventual founder of Gerlach Barklow Art Calendar factory.

Illustrations:
501 Richards today, photo, author
Captain Charles Hill, ca. 1890, Joliet Sketches, courtesy of Jay Reimer
Frederick Hill, ca. 1900, courtesy of Joliet Historical Museum

The Michael Calmer house, 352 Union St.

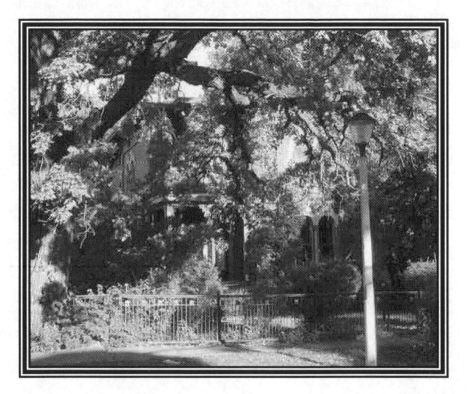

Why it's important: The Calmer house is one of the grand Italianate homes in the city of Joliet designed by local architect James Weese. It is also the home to M. Calmer, dry goods merchant, Civil War veteran and City Treasurer.

Style: The Calmer home is a beautiful example of the Italianate style that dominated American architecture through the last half of the 19th century. The style is seen in the heavy brackets at the roof line, the low almost flat roof, and the rounded top windows. Here the windows are in pairs

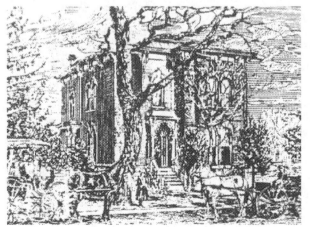

which were very common of the grand homes of the 1870s and 80s. The house also has 2 small porches constructed in the Italianate style.

The history: Constructed in 1880 for a cost of approximately $20,000, the Calmer home was a model of the well outfitted large Victorian home. The original house was smaller than it appears today. Originally there were the main formal rooms on the main level with a kitchen and dining room in the basement and bedrooms upstairs. The house may have been expanded at an early date to accommodate a kitchen on the main level.

Around the turn of the century the small front porch was removed and a massive neo-classical porch was added. The classical details were further enhanced when the second family to own it,

Samuel Chaney, added a stained glass window on the staircase. The widow is a portrait of Chaney's daughters riding on horseback. The window is decorated on the exterior with a classical pediment.

Over the year the house has served in several capacities. From around 1938 until 1946 it was the Colonial Tea Rooms owned by William & May Loughran. The home eventually became apartments in the 1960s and 70s.

The Calmer home was on the verge of becoming another of Joliet's great losses when Tom Roach and his wife Sue heard about it through friends. Abandoned for several years and cut into 11 rental units, the house had already been stripped of its interior and was awaiting demolition when Tom negotiated a purchase price of $500 for the home. It took Tom and Sue 2 years to clear out the house and prepare a portion of it to move into. That same year they were flooded out, but continued working.

Over the next year they worked to locate and purchase back the woodwork for the house. Several pieces had been sold separately and had to be tracked down. It also took several years to reacquire the stained glass window. To date they have spent approximately 3 times their purchase price reassembling the interior.

The house is now surrounded by an iron fence that once stood around the old St. Joseph Hospital on Broadway. There is also a massive ancient Oak Tree which is well documented as one of the largest and oldest Oaks in the area. This tree is visible in every historic image of the home.

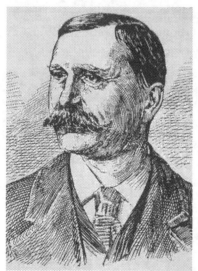

Details: The Calmer house is full of wonderful detail on the exterior and interior. The rear porch is the only original porch on the structure and has been carefully restored. The front porch is a replacement recreating the original look of the home. In the cornice line on the top of the structure there are attractive round attic windows which help enhance the architectural style.

The interior of the home has most of the original woodwork. There are also beautiful inlaid hard wood floors on the first floor. The staircase is detailed with the stained glass portrait window which took the owners several years to acquire to reinstall in the house.

The people: Michael Calmer was born of Hamburg, Bavaria, Germany. He came to the United States with his family in 1852 when he was 10 years old. He lived and worked on the family farm near Mokena until 1862 when he enlisted in Company C 100th ILL Volunteer. He served through the war and mustered out in 1865.

In 1867 he moved to Joliet and married Theresa Stoekig. That year he went into the Dry Goods and Grocery business. He worked first with Mr. Mahoney and the Mr. Sans before establishing M. Calmer Dry Goods in 1872. His store was located on Jefferson St. and was very successful through the 19th century. In 1887 Mr. Calmer was elected to the position of City Treasurer.

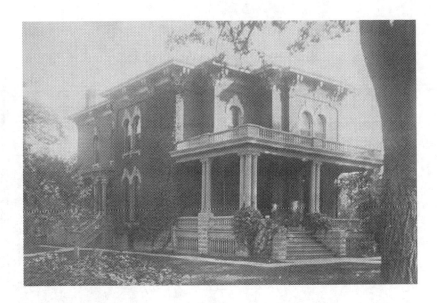

Did you know? After James Weese designed the Calmer house, and the Calmers moved, Mr. Weese moved into M. Calmers old house located on Second Ave. near the end of Sherman St.

Illustrations:
352 Union today, photo, author
352 Union, 1887, Joliet News supplement, August 18th, collection of author
Michael Calmer, 1887, Joliet News supplement, August 18th, collection of author
352 Union, ca. 1911, collection of author

The Clement Witwer home, Cass St near Youngs Ave.
(Demolished)

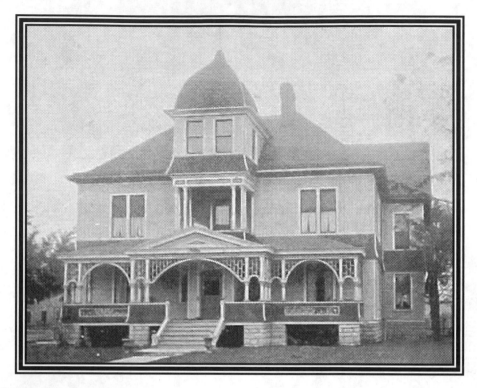

Why it's important: The Witwer home was one of the Grand Queen Anne homes that once lined Cass Street in Joliet. It was also the home of prominent businessman Clement Witwer.

Style: The Witwer home was a stunning example of the Queen Anne style. It was atypical as it had a symmetrical façade. The center was dominated with a 3 story tower topped with a Helmut Dome. The Queen Anne is also seen in the long heavily detailed porch.

The history: The Witwer home was constructed on Cass Street in the mid 1880s. By the time of its construction, Cass was already a popular residential strip. Clement Witwer was building his fortune at the time of construction.

The house served the family well for many years, and like many grand old homes became a funeral home. The Witwer home was the home of O'Neil Funeral home by 1940 and remained O'Neil funeral home until the mid-1970s when it relocated to Lockport.

Today the site of the Witwer home is McDonalds at 508 Cass St. After the O'Neil Funeral home moved to their current location in the mid-1970s, the home was demolished.

134

Details: The Clement Witwer home was a fine example of the Queen Anne style. Though the floor plan and symmetrical façade are reminiscent of the earlier Second Empire and Italianate styles, all the decoration is fully Queen Anne. The long full front porch with the detailed spindle arches is a clear example of that.

The central tower has always been one of the most beautiful things on the house. The second floor of the tower was cut out to allow an open upper porch on the façade. The tower continues then to the Helmut dome which caps the whole look.

The Queen Anne is also seen in the middle of the home in the band of cut shingles which are

painted in a contrasting color. This design element was very common on many grand and simple homes in Joliet.

The people: Clement Witwer was born in Ashland County Ohio, in 1862. During his early life he traveled with his family to their various locations in Indiana and Missouri. From 1879 until 1881, Clement worked as assistant to Studebaker Bros. In the years 1881-82 he attended DePauw University.

In 1883 he went to Dallas Texas, and then returned and eventually found his way to Joliet where he became part interest holder in the Joliet Manufacturing company. The company had been founded in the 1840s in Plainfield IL, and in 1863 moved to Joliet where it located near the corner of Cass Street and Youngs Ave, behind the site of the Witwer home.

In 1887 Clement Witwer married Mary Shreffler of Joliet. This is about the time the grand home on Cass was built. Over the years the company grew and eventually in 1897 Mrs. Witwer was elected treasurer and president of the company, and Mr. Witwer was elected vice-president and manager. The products of the plant were shipped to all parts of the country and the company held an excellent reputation for perfection of machinery.

Did you know? The Witwer home on Cass St. was named "Tarryawhile".

Illustrations:
Witwer home, 1897, Joliet Illustrated, courtesy of the Joliet Public Library
Clement Witwer, ca. 1905, Come to Joliet, courtesy of Joliet Public Library
Joliet Manufacturing, ca. 1905, Come to Joliet, courtesy of the Joliet Public Library

The George and Edwin Munroe house, East Cass St.

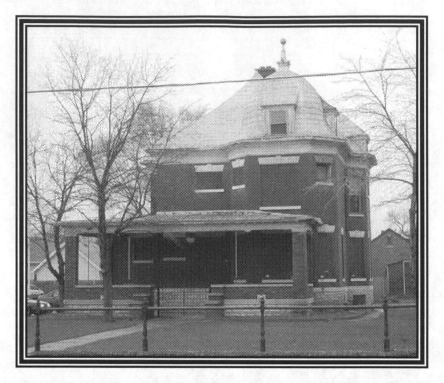

 Why it's important: The Munroe house was home to two of the major players in a very influential Joliet family. It is also noteworthy for its design.

 Style: The Munroe home is an excellent example of the Queen Anne style. This is seen in the asymmetrical massing dominated by the tower. The tower is topped with one of the finest Helmut domes in Joliet. The Queen Anne style is also seen in the steeply pitched roof. A Classical porch was added later to the home.

 The history: The Munroe home was constructed in 1887 by the elder George Munroe. At the time of construction, the house sported a smaller wood Queen Anne porch. The home was built in a very affluent stretch of Joliet Real Estate.

Various other wealthy Joliet citizens built large imposing homes lining Cass St.. From Collins to Henderson a line of stately homes with lush greenery lined Cass. People such as the Stevens, Witwers, and Swinbanks played host to this suburban setting.

The home was passed to Edwin Munroe around the turn of the century and was remodeled to suit the current taste for large porches. The home was heavily pictured throughout its lifetime as one of the fine Joliet homes.

As the area slowly changed over the years, many of the great homes were lost and replaced by a bank, fast food, and even vacant lots. The Munroe home is one of but a few of the elegant homes left along Cass St. Perhaps the fact that it is tucked in next to a large building which hides the site has helped it survive. Today it is privately owned, and much work is going on in the revitalization of the area, and the Munroe home is currently undergoing rehab work and landscaping.

Details: The most phenomenal feature of the Munroe home is the still existent embossed metal roof. Each shingle is embossed in a pattern, and the structure is topped with elaborate cresting and finials.

Other fine features of the home include the detailed brick work of the window hoods, and the great detail of the sprawling front porch.

The people: George Munroe was born in 1821 in Lanarkshire, Scotland. He was one of three children, and came to the United States in 1827. The family came to Joliet in the early days of settlement and the father worked in the Woolen Mills.

In 1849 George settled in Florence Township and engaged in farming. In 1862 he was elected sheriff and in 1865 along with his son the honorable George Munroe opened a Grocery Store in Joliet. In 1884 they constructed the first large building on Chicago Street which became to Hotel Munroe. He was senior partner until his death in 1890.

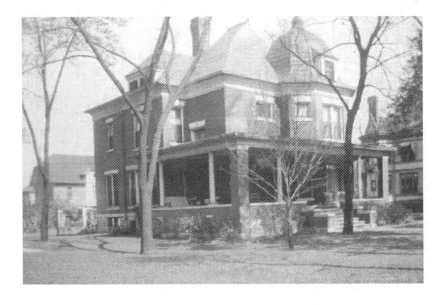

Major Edwin Monroe then inherited the house and came into prominence in Joliet. He was born in 1857 and had already established himself in the family business. Aside from the Hotel and Business block, he along with his brother formed the largest real-estate firm in Joliet.

Major Monroe served in the Illinois National Guard for many years eventually rising to the rank Major. He was married and fathered 3 children.

Did you know? The Helmut dome is so named because it was thought that it looked like the Helmets worn by the Prussian (German) Army.

Illustrations:
Monroe home today, photo, author
Monroe home, 1900, Come to Joliet, courtesy of Joliet Public Library
Edwin Monroe, 1900, Come to Joliet, courtesy of Joliet Public Library
Monroe home, 1916 Artworks of Joliet, courtesy of Andrea Magosky

The Harlow Higinbotham home, Route 30 east of Joliet (Demolished)

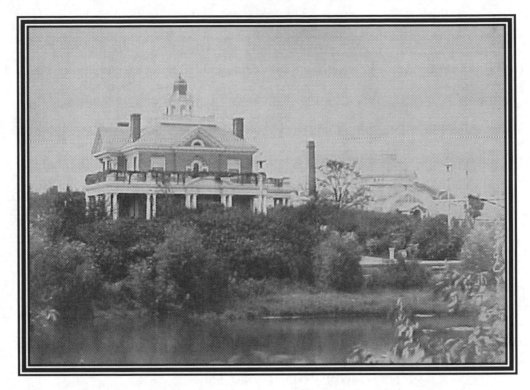

 Why it's important: The Higinbotham home was constructed in 1893, the year of the Columbian Expo. It was built for the president of the fair and vice president of Marshall Field & Co. The home was also an excellent example of the Georgian Classical movement inspired by the fair.

 Style: The Higinbotham home was a massive Georgian Revival home with a sprawling neo-classical front veranda and decorative cupola atop the steep flat topped hip roof. The garden structure was a wonderful greenhouse structure built in that great traditional style.

The history: The Higinbotham home was situated outside of the city limits on East Cass Street. It was constructed in 1893 for the family of Harlow Niles Higinbotham. But the site has a much richer history than just this great home.

The western edge of the property was the site of the old Joliet fairgrounds. Established in the mid-19th century, the fairgrounds were a very developed and popular site by the early 1860s. It was here that the 20th IL. Infantry and the 100th IL Infantry mustered up before setting off to the Civil War. By the 1870s, it was a beautiful park setting as seen in the illustration.

The eastern edge of the Higinbotham site still contains the Cherry Hill Road Cemetery, an early pioneer and rural cemetery. One of the main graves is that of the Thompson family who owned a large estate house which was later owned by Senator Barr. When the house burned to the ground, the area just east of the cemetery was laid out into the current subdivision.

Across Rt. 30 from the home was the Gardens of Arden, a private park commissioned by Higinbotham. Between the park and the house was a private train stop to take Harlow in and out of downtown Chicago.

The home was not used for long before being left to a care taker. The family moved to Chicago to stay, and by the 1930s, was just a hollow old home falling into disrepair. Some people still recall the great old house before it finally succumbed to nature.

Details: The Harlow Higinbotham house was designed by Daniel H. Burnham, chief architect for the 1893 Worlds Fair in Chicago. The home was a reflection of the Classicism that was sweeping the nation in the 1890s.

The most prominent feature of the house was the full-length Classical veranda which overlooked the lagoon and Cass Street. The house was also topped by a wonderful cupola and decorative Georgian balustrade. The massing of the house reflects the traditional Georgian balance with the impressive Palladian window in the center front.

The estate had several out buildings including a greenhouse, carriage house and massive barn. For many years the barn stood to the east of the site. It finally burned down in the 1970s.

The people: Harlow Niles Higinbotham was born in Joliet. He was the child of Joliet's H.D. Higinbotham, who was born in Ostego County, New York. His mother was Rachel Wheeler, born in Westford, New York. Harlow was born in the family home along the banks of Hickory Creek on October 10th, 1838.

Harlow was married to Rachael Davidson of Joliet. In the late 1860s, he became engaged in the mercantile house of Field and Leiter & Co. on state St. in Chicago. He rose in position over the years. One very important part he served in the company came in October of 1871. When the great Chicago fire devastated the entire business district of Chicago, Marshall Field sent Levi Leiter's family as well as all of the saved financial records for the store to stay with Harlow in Joliet.

In the days just after the Chicago fire, Marshall Fields was financially run from Joliet. Harlow would eventually rise to the position of vice president of the company when he retired a millionaire. He was very involved in many projects and achieved his greatest position as president of the 1893 Columbian Exposition in Chicago which celebrated the 400th anniversary of the discovery of America.

Mr. Higinbotham moved to Chicago when he left his house and after his death was buried in Graceland Cemetery in Chicago. He is

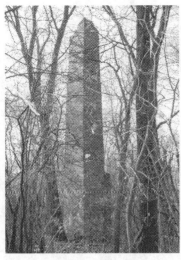

buried along the lagoon in line with the other great merchant princes of Chicago.

Today: Although the original Higinbotham house is gone, the property is still owned by the descendants, and there is a later home on part of the site. The lagoon is still visible as you pass on Route 30 heading east from Joliet. The private gardens were purchased by Robert Pilcher and given to the City of Joliet. They survive today as Pilcher Park.

Did you know? Harlow Higinbotham hired Ossiand Simonds to design his Gardens of Arden. Simonds was also the landscape architect for the Mortem Arboretum.

Illustrations:
Higinbotham estate, ca. 1910, courtesy of Joliet Area Historical Museum
Higinbotham site today, photo, author
Garden of Arden, 1909, Joliet in Photographs, collection of author
Ruins of barn today, photo, author

The John B. Mount home, 109 Third Avenue

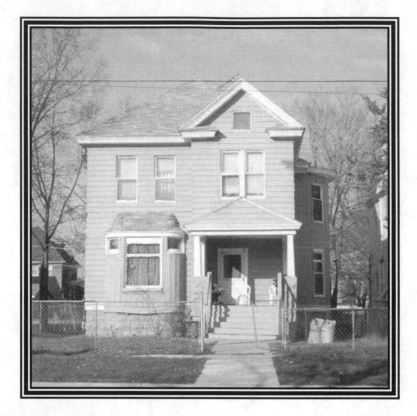

 Why it's important: The home at 109 Third Avenue was the residence of turn-of-the-century mayor of Joliet, John B. Mount. It is also an interesting blend between architectural styles.

 Style: The Mount home is a cross blend of the Queen Anne style dominant in the late 1800s and the coming Colonial Revival style starting to come into fashion. The Queen Anne is seen in the rounded bays and asymmetrical massing. The colonial Revival is seen in the modified pediment over the entry, and returns in the eaves.

 The history: The Mount home was constructed in the 1890s on what was one of the premier streets in Joliet. At that time such families as the Woodruff's, Barrett's, Bruce's, and Meers lived along this street. The homes were amongst the finest in the area. The Mount home at 109 is no less grand than its neighbors.

The Mount family resided in the home from its construction through the 1910s. The house was then lived in by the Johnson family, and then in 1912 was purchased by the William Elwood family who lived in the home through most of the rest of the early 20th century.

The John B. Mount home has today been converted into a multi-unit apartment building as so many of the grand homes along Third Avenue. Although sided, it still maintains the original form, and maybe some day this home will be restored to its former glory.

 Details: The John B. Mount home is an excellent blend to 2 styles. The Colonial Revival is seen in the main front. The large area over the front entry has Returns on the eaves which mimic the

earlier Greek Revival style, but here are used in the Colonial Style. The east side of the house has a semi-circular room which almost creates a tower. This feature, along with the decorative bay on the front and the asymmetrical massing, reflect the Queen Anne style.

Although sided, many of the original windows and features are still visible on this structure. The entry hall of this home still hosts the original grand staircase.

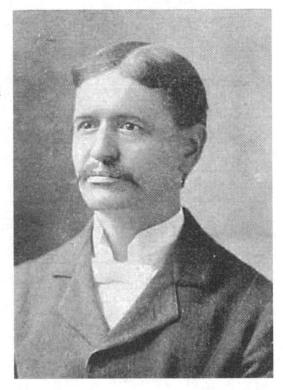

The people: John B Mount was born in 1859 in Jacksonville IL. He was educated in the public schools of Jacksonville, and upon graduation entered into the Drugstore business as a clerk. There he learned all about the business, and in 1882, he moved to Joliet and opened his own store on the corner of Jefferson and Chicago Streets.

The Mount drugstore would remain in that location until 1895 when it moved to its final local on Washington Street. Mr. Mount became quite involved in politics and served in a succession of offices. He served four terms as assistant supervisor, city treasurer and, after more than one attempt, served as mayor at the turn of the century.

Did you know? John Mount sold his large home in the early 20th century to live in a duplex. His second home is a large greystone duplex on Sherman Street.

Illustrations:
109 third today, photo, author
John B. Mount, 1897, Joliet Illustrated, courtesy of the Joliet Public Library

Bibliography

Biographical Publishing Company. <u>Genealogical and Biographical Record of Will County Illinois</u>. Chicago, 1900

Chapman Brothers. <u>Portrait Biographical Album of Will County Illinois</u>. Chicago, 1890

Daily Republican. <u>Joliet Illustrated</u>, Historical, Descriptive and Biographical. Joliet, 1897

Gravure Illustration Company. <u>Art Work of Joliet</u>, Illinois. Chicago, 1895 & 1916

Joliet Business Men's Association. <u>Come to Joliet</u>. Joliet Republican Printing Co., Joliet, 1900

Joliet News. <u>Joliet in Photographs, Giving a Report of Possession and Present Conditions</u>. Joliet, 1909

Joliet News. <u>Supplement for the Business Men's Association</u>. Joliet News Printing Company, August 1887

Maue, August. <u>History of Will County Illinois</u>. Historical Publishing Company, Topeka & Indianapolis, 1928

Municipal Development Company. <u>Greater Joliet Illinois</u>. Chicago, 1913

Polk, R.L. & Co. <u>Polk's City Directory</u>. Joliet, 1903-04, 1905-06, 1908-09, 1812, 1914, 1916, 1918, 1920, 1921, 1923, 1925, 1927, 1930, 1932, 1933-34, 1938, 1940, 1955, 1960

Polk, R.L. & Co. <u>Wiggins' Joliet City Directory</u>. Joliet, 1896-97, 1899-1900, 1901-02, 1902-03

Sanborn Map Company. <u>Joliet, Illinois</u>. New York, 1891, 1898, 1924, 1924 with 1950 updates

Seymor, Lester Company. <u>Directory of the City of Joliet</u>, Joliet Republican Book & Job Printing House, Joliet, 1875

Stevens, William Wallace. <u>Past and Present of Will County, Illinois</u>. S.J. Clarke Publishing, Chicago, 1907

Withey, Henry F. & Elise Rathburn. Biographical <u>Dictionary of American Architects (Deceased)</u>. Hennessey & Ingalls Inc, Los Angeles, 1970

Woodruff, George. <u>The History of Will County Illinois</u>. Wm. Le Baron Jr., & Co, Dearborn St Chicago, 1878